REVIEWS

If a copy of "Her Art of Surrender" has found its way into your hands, trust me when I tell you it was not by chance. This is fate. With each story found in the pages of this book will come into a deeper understanding of the way we are all connected on a soul level. You see, we were never meant to be strangers living our separate lives. We were never meant to share only the beautiful moments. We were never meant to carry the fear, the burden or heartache of struggle alone. We are a sisterhood and it is our time to rise together through the empowering art of surrender. This book is a gift to the world and an invitation to women throughout the Universe to embrace their stories and embark on the greatest journey of all. The journey of surrender. So, lovely one, go ahead...open the book, your world is about to change.

-- Arielle Coree - https://ariellecoreeco.wixsite.com/home

With every page I turned my soul was nourished more and more. Each chapter containing it's own powerful story, and yet I could see and feel myself in all of them. How freeing to know you're not alone in how you feel, especially in the most tumultuous of times, and to see example after example that powerful healing is on the way. As a recovering perfectionist and control queen I can honestly say that surrender has been the most life altering journey I've ever embarked upon, and "Her Art of Surrender" beautifully escorts you further down your own path, regardless of where you're at right now. A brilliant book I already know I will be sharing with anyone and everyone I know...

-- Jennifer Jayde - International best selling author, speaker, and spiritual teacher - Victoria BC + San Diego CA - www.jenniferjayde.com

We all possess the desire to create our own destinies. But have you ever wondered what it would be like if you just let go? The stories in, Her Art of Surrender, show the beauty of what happens when you surrender to the flow of the Universe and let destiny take its course.

-- Jasmine June-Cabanaw - Author, Publisher
www.greenbamboopublishing.com

REVIEWS

Her Art of Surrender is an enlightened journey through the teachings of a sacred 'art' illuminated through various experiences. This book is a powerful reminder that the path to surrender may not always be beautiful, but what is on the other side, is extraordinary. I felt deeply connected to each author and could not put the book down. I would recommend this masterpiece to anyone who desires to be enlightened and connect more deeply with their spirituality."

-- Sabrina Greer – 2x Best-Selling Author, Entrepreneur, Mama-Empowerer and Founder of YGTMAMA.INC www.ygtmama.com

HER ART OF SURRENDER

A COLLECTION OF STORIES ABOUT LETTING GO
OF THE PAST AND EMBRACING THE SOUL

Barb,
Oh my goodness!
Do it up girl! Your
energy is contagious,
hilarious and also warm
and sincere. Thank you for
being here this weekend
and for loving on
me. It means
so much! ♡
Love always,
- Cassie Beans

HER ART OF SURRENDER: A COLLECTION OF STORIES ABOUT LETTING GO OF THE PAST AND EMBRACING THE SOUL

2018 Golden Brick Road Publishing House Inc.
Trade Paperback Edition
Copyright @ 2018 Cassandra Jeans

Published in Canada for Global Distribution by Golden Brick Road Publishing House Inc.
www.goldenbrickroad.pub

FOR MORE INFORMATION EMAIL: HELLO@CASSIEJEANS.COM
ISBN:
trade paperback 978-1-988736-44-0
ebook: 978-1-988736-45-7
Kindle: 978-1-988736-46-4

To order additional copies of this book: orders@gbrph.ca

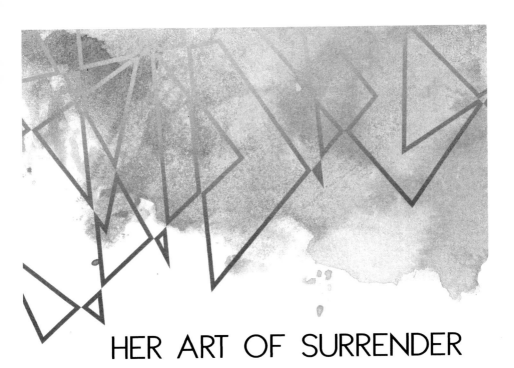

HER ART OF SURRENDER

A COLLECTION OF STORIES ABOUT LETTING GO OF THE PAST AND EMBRACING THE SOUL

BY **CASSIE JEANS** AND CO-CREATORS:

Leisa Nadler,
Miranda Sophia,
Effie Mitskopoulos,
Gagan Kaur Mann,
Charleyne Oulton, Nicole Martin,
Jennifer Boudreau, Sara Gustafson,
Coryn Pawliw, Sarah Rhinelander,
Stephanie Davis, Lauren Janee,
Michelle Tonn, Michelle Chan,
Sonia Greer, Briana Gagne,
Kirsten Stuckenberg,
Tina Schomburg,
Narelle Clyde

CONTENTS

CONTENTS

PREFACE

BY CASSIE JEANS

Why did I choose to write about Surrender?

When we give voice to our pain, to what we hold onto, in the hopes that somehow we will find fulfillment from something outside of ourselves, we create space to embrace our soul work.

Soul work is the great journey to our authentic selves. When we awaken to the realization that holding on has also chained us to areas in our life that we don't even enjoy anymore, we realize there is a nudge to start looking inwards.

Looking inwards, we realize there are a lot of questions for us to ask ourselves. Is this what I want? Am I okay with this? Do I even know why I am living my life this way? Is there something else for me? Who do I want to be?

This journey will shake things up to say the least. Change is a guarantee, possible heartache, tears, and discomfort almost certain... so why go through all of this? Why open up our hearts to this?

This is why. At one point, the life we were living was choking us from the inside. Living this way became intolerable and acknowledging how we were actually feeling was the catalyst for the greatest adventure of our lives. When we realize our value, it becomes impossible to silence the voice from within that is asking us to rise into claiming our whole life, not just the bits and pieces of what is accepted as "normal."

In this we find the sweetest embrace of freedom, hope, deliverance.

Surrender is sacred. The steps each of us go through in order to be able to surrender to our authenticity require curiosity, bravery, and a deep rooted faith in the art of letting go of love, of security, and of preconceived ideas about how life is supposed to be.

INTRODUCTION

BY CASSIE JEANS

Her Art Of Surrender is a collection of stories. Stories written from women all over the world with a variety of different backgrounds, beliefs, and experiences. Many of us have never even met in person yet we were all drawn together by a single word. Surrender.

Not to be taken lightly, this book is not about giving up, waving a white flag on our lives, and handing our power over. Quite the contrary.

This book is about the power of surrender. When we let go, what are we left with?

Beneath the surface of each of these women's lives runs a current of electricity, vibration, and spirit. This reservoir is available every time we create space in our life for our calling, for our voice, for our art, for our health, for the sovereignty of our life.

The space comes from the act of surrendering that which no longer serves us, that which we cannot control, and that which demeans or keeps us small in any area of our life.

As you read these stories, allow yourself to feel them. Allow yourself to see your own life in their words.

A few questions that would be helpful to ask yourself while reading are:

1. Is there a part of my life story that I see in these stories?
2. Am I seeing the power of surrender?
3. Surrendering is creating space for my growth - are there areas in my life right now that I know I have to surrender?

Briana, Charleyne, Coryn, Gagan, Jennifer, Kirsten, Lauren, Musha, Michelle, Miranda, Nicole, Sara, Sonia, Tina, Leisa, Narelle, Effie, Sarah, and Stephanie are ridiculously brave, heart-felt, and totally

vulnerable. I remember when I asked them why they wanted to do this, there was a unanimous, "If my story can help one woman overcome something in her life, it's worth it."

I get chills when I think of this. Feel free to read this through from beginning to end or to intuitively dip from one story to another.

Remember, you are supported by a thread that each of us weaves together for one another every time we allow a sister to speak her truth and rise.

Sending you an abundance of love and the gift of Her Art of Surrender.

1

BRAVELY BECOMING

*"You have all the power here,
even if you don't feel it."*

BY: LAUREN JANEE

LAUREN JANEE

LAUREN JANEE

Lauren Janee is the founder of Braving the Becoming, a non-profit that inspires and empowers women who have experienced trauma to reclaim their voice and own their stories by providing healing services through online education, survivor communities, and retreats.

Braving the Becoming creates a safe space to openly discuss sexual abuse, domestic violence, and other forms of trauma through community dialogue and social awareness.

Lauren is a creative entrepreneur who tells stories through narrative and design. She is a writer and speaker, and holds an unwavering commitment to telling her truth. She believes it's in intentionality and awareness that we can live out our most expansive, expressive, and meaningful life.

She is the mother of four amazing little humans, including twins, who inspire her to own her story and see the world through the eyes of love. She's an obsessive learner who is constantly reading, dreaming, and drinking coffee. She finds kundalini yoga, journaling, and playing the djembe therapeutic. One of her favorite stories to tell is her journey to losing over 100 pounds. She's a born and raised Midwest girl whose life is in constant motion. She fusses, she cusses, she's got really strong emotions, and she believes in the magic of who you are.

www.laurenjanee.com | www.bravingthebecoming.com
fb: @iamlaurenjanee | @bravingthebecoming
ig: @iamlaurenjanee | @bravingthebecoming

Standing in the middle of my story.

Somewhere between who I was and who I was becoming.

I was shattered trying to figure out how the pieces went together.

Learning to surrender all that I thought I knew.

Unlearning everything in order to become something.

Survivor of childhood sexual abuse.

Adopted daughter of a narcissistic mother.

A woman escaping the grips of oppressive religion.

Survivor of over a decade inside domestically violent relationships.

Single mother of four children co-parenting with two fathers.

Recovering food addict.

Trauma filled my life.

It shaped the voices in my head and drowned out the light.

I hid in the shadows.

I learned how to live half alive.

I tucked away the vulnerable, the authentic.

I learned how to function inside of dysfunction and called it faith.

I thought this was living. Until I wanted to die.

"THE WOUND IS THE PLACE WHERE THE LIGHT ENTERS YOU." - RUMI

THERE ARE MOMENTS IN YOUR LIFE that alter the trajectory of your journey. They bring you to the raw, vulnerable space where you have two choices - continue running or surrender. If you run, you will no doubt find yourself here again until you finally make the choice of surrender. Because surrender is truly all there is. A continual letting go in order to become.

To the women who are survivors of trauma. To those who have experienced deep, emotional pain. To you who are struggling to find the light. I see you. I hear your heart cries. You are not alone.

This is your grief. No one can heal you, only you can choose it. This is your hurt, your pain, your story.

We find ourselves in the middle of our living, unable to experience life. We seek, never finding the cure for our pain. It stays with us. We try everything to silence its voice. To not hear it or see it or feel it. Because feeling it would hurt and we don't want any more pain. So we go on not feeling. Searching for new ways to alleviate the deep sorrow we feel, hoping it lasts this time. But it never does and we find ourselves right back at the beginning. Back at the source of our pain. Broken. Hurting. Lost.

Let me ask you something. What would happen if you could sit still with your pain? If you invited your fears and your suffering to the table and allowed them to show up without judgment or demands?

I know it feels impossible. It's dark. It's scary. It hurts. This place of remembering and yet not fully knowing. How do you find healing and rest, not to mention joy and peace, when the waves of chaos never stop crashing the shore?

But my Friend, here I stand on the other side of impossibility, free and happy. I want you to do the impossible, too.

Transformation begins from the radical acceptance of what is. Trauma is such a defining experience. It's a lie looking back at you that you've accepted
as the truth. What is your truth? What are the answers you are searching for?

Only you can answer these questions by embracing the totality of your life's experiences. Yes, even the dark spaces. Especially the dark

spaces. It's where you'll find your light.

We search our entire lives for meaning, for belonging. For more. Never realizing we belong to ourselves. We belong to the Universe. We are co-creators of our lives with the creator of all things. When we can fall into the grace of that understanding, we can truly find our way into a life that we are absolutely in love with.

Time does not heal our wounds. We do, by repurposing how we think about our pain. When we allow the experiences that have shaped us to heal us, we can find a strength that is not found anywhere else in this life. Pain does not always have purpose, but it always holds the keys to our freedom. The freedom we gain in finding our voice and reclaiming what is ours. As survivors, life wasn't just handed to us. We've had to fight for our place at the table. The control was a necessary part of the process, and so is the surrender.

Unwrite what was written for you. This is your story. You have all the power here.

Danielle LaPorte wrote, *"If you want to increase your joy, deepen your devotion to knowing the truth. The truth of who you are."*

My Friend, I want to know, who are you? Find her, the woman you've always been but have never fully known.

The earth does not slow down for our grief. It keeps evolving. It keeps going. Even when we want it to slow. Even when we want it to stop. Even when we need it to stop. It keeps going. When we can stay in alignment with that movement and understand that we are being supported and guided into the experiences that are for our highest good, we can begin to catch our breath. We can begin to dream. We can allow ourselves to let go of the how and experience the now. We can find ourselves enjoying the movement of each experience instead of fearing the unknown. Instead of trying to control the next step. We simply take the next step. We surrender.

In that surrender, we are no longer silenced by the voices that have drowned out our stories for so long. The past does not define us, but it does shape us. And now we own our choice. We are no longer sacrificing, we are surrendering. We are becoming. This is your life. The only one you get. The pain. The joy. The grief. The recovery. The journey. The awakening. The becoming. It's yours. Messy. Complicated. Raw. Beautiful.

Life is a journey one must embrace to find true freedom. The beautiful, the chaotic, and the moments we desperately want to unlive - all create the unique journey leading to our purpose. When we

start seeing and listening and experiencing new things, and even old things in new ways, we declare that we are no longer captive to our pain but that we are now the authors of our story.

I can say with great certainty and absolute truth, anything you accept fully will lead you to your peace. Surrender to your feelings in whatever form they take without labeling them. Simply allow them to be there and witness the miracle of surrender as your deepest suffering transforms into your deepest peace.

On the other side of surrender is freedom, joy, and transformation. Trust the process. You cannot do this wrong. The fact that you've picked up this book tells me you're already doing it. And you're doing it, beautifully.

Your story is unique and beautiful and it echoes through the hearts of women. You are fierce and strong and full of fire. And we need you. We need you to heal. Because through your healing, you heal others. And together, we can heal a generation.

No longer resist your pain. Transmute it into your purpose.

I want you to know you are immensely loved and cherished. What you think and how you feel matter. Let every other voice that says otherwise, crumble.

Surrender to your story and rise.

ACKNOWLEDGEMENT

*TO THOSE WHO ARE FINDING THEIR VOICE, KEEP SPEAKING.
TO THOSE WHO HAVE HELPED ME FIND MINE, THANK YOU.*

WAKING UP
TO CANCER

*"Cancer was never the cause
of my pain. It was always
the inviation to heal it."*

BY: TINA SCHOMBURG

TINA SCHOMBURG

TINA SCHOMBURG

Tina Schomburg is a lighthouse that points the way to your inner compass. As a writer and poet, she inspires and empowers us to embark on a journey inward to discover the true magnificence within all of us. While pen and paper have always felt like a natural extension of her essence, Tina didn't share her introspective prose until cancer broke her open. This intimate encounter with death set her soul on fire and sent her blazing into the heart of the world. Her writing is infused with so much love that her words have been coined as "soul hugs" by many readers.

Tina has an uncanny ability to bridge spirituality with practicality, offering a down-to-earth perspective of our cosmic existence. Her mission as a social entrepreneur and health activist is to guide others through challenging transitions and personal transformations. With a deep connection to nature, she seeks counsel from Mother Earth, who teaches her the ways of grace through every phase of life and death. With a grateful heart, Tina channels this wisdom through every aspect of her work, challenging us to inquire deeply into the nature of our Self.

Tina operates on the fuel of service, and is devoted to creating a world filled with love and compassion for generations to come. Her daily reminder to lead by example is rooted in the principle that if we heal ourselves, we heal the world. You can track her down to get your daily dose of soul hugs here:

fb @tinaschomburgauthor
ig @tinaschomburg

"DENIAL HELPS US TO PACE OUR FEELINGS OF GRIEF. THERE IS A GRACE IN DENIAL. IT IS NATURE'S WAY OF LETTING IN ONLY AS MUCH AS WE CAN HANDLE." - ELISA-BETH KUBLER-ROSS

I T WAS NOVEMBER OF 2011. I was twenty-one years young when my world got turned upside down by cancer. I wish I could say that I didn't see it coming, but all the signs were there. It started with a nervous breakdown, which I quickly dismissed as a moment of weakness and got busy living again. But then there were the night sweats, and an itch so deep beneath my skin it couldn't be alleviated, no matter how hard I tried. I remember being on calls with clients, scratching my skin until it bled. Over the span of a few weeks, I was covered in bruises and scabs. My body was screaming at me, but I was too busy to pay attention.

The one thing I couldn't keep ignoring was the pain underneath my left rib cage. It felt as though I had been stabbed, and the knife was being twisted and turned in all directions. The periods between these agonizing episodes grew incrementally smaller. Every day, the pain got a little worse.

One warm Autumn evening, I was at the beach drinking with some friends. I sat on a log facing the ocean. A deep silence filled my body. It's not good, I heard a whisper from deep within. It's cancer. I wasn't sure if I was ready to face that fate. I didn't know if I would be strong enough to survive, or even wanted to fight for my life. All I knew was that I couldn't keep lying to myself.

After two weeks of scans, tests, and too many needles to count, I laid on a hospital bed waiting for a bone marrow biopsy when a nurse walked in with a stack of brochures. Living with Cancer, Cancer Support, Leukemia and Lymphoma Information - I read the headings.

"Has anyone given you these already?" she asked.
"No one has even told me that I have cancer," I retorted.

The next day, I glazed over the chemotherapy schedule in the doctor's office. I had spent hours researching cancer, in an attempt to understand a disease that had no easy explanation. *Most people die from chemotherapy, not cancer.* It rang through my head.

"There isn't much time to decide," my oncologist pressed impatiently.

I was angry at her level of insensitivity. Have you ever been told that you have cancer? No, you just study this crap, I thought and walked out of her office. That was the last I saw of her. I declined chemotherapy, and resolved to heal my cancer naturally.

I moved to Costa Rica and started a strict detox regimen I had created, based on the most successful alternative cancer therapies. My parents, like most others, thought I was crazy, but knew better than to argue with me.

"Give me a year and I will do another scan. If the cancer grows, I will do chemotherapy. If it doesn't, I will continue to do it my way," I proposed confidently. We shook on the deal.

I thought I would be the young woman who defied not just cancer, but the entire medical establishment by curing the disease naturally. My confidence gradually wore off over the next nine months. It was difficult for me to accept that maybe this wasn't how things were going to happen.

I felt ashamed at the thought of not finishing what I had set out to do. What would people think? The idea of being perceived as a failure, which in my mind was the only possible outcome, terrified me. So I continued to pretend that everything was fine, until I couldn't any longer. Back home on Canadian soil, I was mentally and emotionally exhausted.

The one-year follow-up CT scan showed that the tumour had grown minisculely (0.03 millimeters to be exact). "Looks like whatever you're doing is helping to keep the cancer at bay." My doctor looked up from the report. "But it might always just do that - keep it in check. Don't you want the cancer to be gone?"

I was tired of fighting and ready to surrender. "I do," I said, and prepared myself for chemotherapy.

MY DARK NIGHT OF THE SOUL

"THE WORD 'DEPRESSED' IS SPOKEN PHONETICALLY AS 'DEEP REST.' WE CAN VIEW DEPRESSION NOT AS A MENTAL ILLNESS, BUT ON A DEEPER LEVEL, AS A PROFOUND (AND VERY MISUNDERSTOOD) STATE OF DEEP REST, ENTERED INTO WHEN WE ARE COMPLETELY EXHAUSTED BY THE WEIGHT OF OUR OWN (FALSE) STORY OF OURSELVES."
- JEFF FOSTER

IT HAS BEEN SIX YEARS since I was diagnosed with cancer, four years of which I have been in remission. Living with cancer, even in the absence of the disease, has been the most transformative experience. It has shaped my life in ways that I could have never imagined possible.

What I learned cannot be distilled into a nicely packaged formula for how to avoid cancer, or even how to live life to the fullest while doing justice to everyone who has experienced it or died because of it. All I can offer, here, is to share what I have experienced, and it might not be what you'd expect.

For the next six months, I would sit in a sterile room for up to five hours having needles stuck inside me, connected to beeping machines and liquid bags labelled as toxic. That, however, was just one day, every two weeks. In between, it was the first time I allowed myself to shift my focus from productivity to idleness.

In this state of non-doing, I read and wrote daily – two activities I loved but that had fallen lower on my priority list since joining adulthood. I found solace amidst the forest on a mountain side behind the house I was living in. Sometimes, I would rest in the bath for hours and just watch the trees sway to the rhythm of the wind. It was during this time that the pace of my life was slow and quiet enough for me to hear my own thoughts and notice the subtle changes in my body, and how I was feeling.

I am grateful to cancer for offering me such a pertinent opportunity to remember this way of being and living, which was independent of my output. Growing up, I always had the eerie feeling that my worth was slavishly tied to productivity.

Once I joined the workforce, I suppressed that thought as a coping mechanism. I got busy, and would drown myself in an endless to-do list, like everyone else.

When my oncologist announced that I had no more cancer in my body, I didn't feel like celebrating. A profound sadness nestled into every cell of my being. I felt trapped in an experience I no longer wanted to have.

The idea of returning to a life where my value was deduced to the worth of my output, according to the standard of a society that seemed as ill as I once was, made me feel resentful about being alive.

I would think of all the obligations to do things – to please someone, and to meet the expectations to be something I wasn't – just to be accepted. I remember thinking of orcas trapped in fake environments with constant spectators waiting for them to perform. No wonder they go crazy and turn into killers. That was not how I wanted to spend my life. I was tired of performing and pretending. I needed deep rest. And so once again, it was time to surrender. .

COMING OUT OF THE SHADOW

"DON'T LOOK FOR ANY OTHER STATE THAN THE ONE YOU ARE IN NOW; OTHERWISE, YOU WILL SET UP INNER CONFLICT AND UNCONSCIOUS RESISTANCE... SURRENDER TO WHAT IS. SAY 'YES' TO LIFE – AND SEE HOW LIFE SUDDENLY STARTS WORKING FOR YOU RATHER THAN AGAINST YOU." - ECKHART TOLLE

On my twenty-eighth birthday, I got honest about how I was feeling. For the first time, I shared some of my darker thoughts with a friend, despite being afraid of how I might come across. "You know," I said, "Sometimes it feels like I don't want to be here. If tomorrow was my last day, it would be kind of a relief."

I remember the way she studied me with concern. "I am not suicidal," I reassured her.

After a moment of silence, she carefully spoke. "You know that's just a thought, right? You don't have to believe everything you think."

I knew I didn't come out of the womb proclaiming, "I don't want to be here!" None of us do, and still, many develop a silent fear that this place is not safe for us to exist in. Somewhere between infancy

and adulthood, we learned to suppress our feelings.

When I opened up to my friend, I took a risk. What if she labels me as depressed or tells me that I'm too negative to be around? What if she thinks that there is something wrong with me, or worse: what if she doesn't care?

We all have our own version of worst-case scenarios. Most of them boil down to a fear of losing people we love and becoming social outcasts. For me, the idea of sharing my darkest thoughts and feelings was more terrifying than the fear of dying alone. And still, it seemed at the time as if I had no other choice but to express what I was feeling - no matter the consequence.

In the end, cancer didn't break me. It broke me open, and made me realize how hard I had grown to the world around me. I built layers upon layers of protective armour around my heart, preventing anyone from getting in, and everything from getting out. Cancer was never the cause of my pain. It was always the invitation to heal it.

One in every three women will develop the disease in her life-time. If you are a man, your chances go down a little, but even then, every fourth will face cancer. What has always bothered me about those rising statistics is that no one seems to question them. Why are we getting sicker when science and technology are supposed to be more advanced than ever before?

I believe that as a whole, we are in complete denial about our individual and collective pain. We put on a tough front and pretend as if we aren't hurting inside. Yet we have such a difficult time being in silence. We dread being alone with our thoughts, so we seek to fill every moment with outside noise. We escape into the realms of social media, living vicariously through the lives of others, just so that we don't have to live our own.

Once cancer woke me up, I saw how little I showed up for my life. I felt how much I held back, and observed how judgmental I was towards myself and others.

I believe it is important, and helpful, to acknowledge that we live in a world where pleasure is idolized and pain is demonized. In this dualistic thinking, we have learned to label emotions as either "good" or "bad." When we feel sad, angry, or ashamed, most of us don't al-low ourselves to experience it. Instead, we suppress the emotion and distract ourselves. We become afraid of what might happen if people find out that we aren't always grin-faced happy, and ecstatic to be alive.

I have never met a woman who hasn't been told that she was "too much," or "too emotional." Men, too, have been conditioned to mask their pain. "Don't cry!" they are told. We have mistaken darkness for negativity, and act as if it is contagious.

The thing is that our feelings don't go anywhere until they are expressed. They pile up inside, and the longer we allow this to happen, the more bitter and resentful we grow. We blame everyone else for how we feel. Like the example of the orcas held in captivity, we become isolated in our pain, and turn on the ones who are here to help. That is how we suffer, and make everyone else suffer with us. It's a vicious cycle that will not end until we grow tired of suffering alone, and commit to our own healing by loving, expressing, and accepting all that we hide. It is in the untold stories of our wounds that we find the greatest healing.

THE LIGHT THAT YOU ARE

"THE WOUND IS WHERE THE LIGHTS ENTERS." - RUMI

I am not going to sugarcoat how difficult it is to surrender. It feels like death, because essentially it is. The process of surrender demands that we allow ourselves to die over and over again. That takes a tremendous amount of courage, because at any point, we always run the risk of losing something.

I've encountered many deaths on my journey. Since cancer, I have let go of friends, jobs, money, homes, and a long-term partnership. While painful, all of that was necessary so I could find myself once again. From every loss, something new arose.

Now I look at my life, and I am surrounded by people who I trust deeply to be myself with. I have learned, and still am learning, how to allow others to be who they are. Sometimes, I get triggered by something they say or do that makes me feel uncomfortable, but I am starting to see beyond the initial emotional response. Each time, it is merely a window to another part of me that is asking to be loved and accepted.

Every time I have taken the risk of losing something, by surrendering to what is, I have been rewarded with more than I could have imagined. Life didn't always show up in ways I expected, or even wanted, but it has always delivered exactly what I needed. Sometimes

that was a hard-knock rejection. Other times, it was unconditional support. Neither was better than the other. Both were perfect in their own right.

Naturally, some days we find it easier to stay centred, grounded, and open to the unexpected. Other days, we want to bang our head against a wall and curse the sky. That doesn't make us bad or wrong, just human. There will always be people and influences that try to convince us that who we are and what we do is somehow not enough.

May you remember in those moments of scrutiny and doubt that there is no right or wrong, just like there are no good or bad feelings. Whatever path you choose to embrace is ultimately for you to decide. If you feel like struggling for days or weeks because you are not willing to accept what is, then so be it. Surrender is always just one choice away. You can step into it whenever you're ready.

I only found the strength, and the will, to surrender in the face of death. As I reflect on my cancer journey, the hardship I have faced, the pain I have endured, and the joy I have felt, I wouldn't change a thing. I feel at peace, and that, to me, is the ultimate reward for surrendering to life.

A NEW CHAPTER

While putting the finishing touches on this chapter, I received a call from my oncologist. It's cancer, again. What a plot twist, indeed! As I end this chapter and begin another, I trust that the new cancer diagnosis is yet another invitation for me to heal. I am grateful for the opportunity to share my journey this far, and thank you for taking the time to read about it. The greater intention behind opening up about my experience, however, is for you to discover your own.

May you find your own healing in the untold stories of your wounds - through the art of surrender. And so be it.

ACKNOWLEDGEMENT

TO MY PARENTS AND BROTHER; MY PARTNER IN CRIME AT THE TIME, MY INCREDIBLE FRIENDS; MY INVISIBLE HELPERS, AND MY SELF - THANK YOU. I LOVE YOU.

3

SURRENDERING TO LOVE

"This quest for self-love should be the only battle we fight."

BY: SONIA GREER

SONIA GREER

SONIA GREER

Sonia is an inspiration with a heart as big as her personality. She is a spiritual guide, energy healer, and yoga teacher. Originally holding a master's degree in business, Sonia had a successful sixteen year career in corporate procurement before a burn out which led to a complete change of life.

At the age of sixteen, she dreamt of writing self-help books and being a psychological support to her fellow humans, as she seemed to attract those needing love and guidance. But as she started University and a degree in psychology didn't resonate with her, she went on to study business.

She became passionate about energy healing after it helped her out of depression at the age of twenty-one and decided to train in that field as she started her deeper spiritual journey. It felt like a natural ability she always had to heal and guide people, and it provided her the outlet she had sought for so long to support others on their journey. She went on to train in various other healing modalities such as Reiki, Ho'oponopono, and Shamanic healing.

She travelled and lived in various countries, including the Middle East, where her love for yoga was born. Discovering this other form of healing both physically and emotionally drove her to train as a yoga teacher.

She has always been deeply spiritual, believing everything happens for a reason, that life is a gift we must cherish, and to always look on the bright side.

fb @sonia.hamdi.520 | @themindfulwigwam
ig @iamsoniagreer | @themindfulwigwam

SURRENDERING IS A JOURNEY. I struggled at first to understand what it means to surrender. As a native French speaker, I had a rough understanding, but there was so much emphasis from the spiritual community on how essential it is that I looked it up. A strict translation is to abandon, capitulate, ultimately stop fighting. I think that's the one that resonates with me the most: Stop the fight. Just let it be, ride the wave, flow through life, not forcing it, naturally.

That has been the difficulty for me. I used to need to control, plan, overthink, strategize. I have now realized that the best things happened in my life when I was in alignment with myself, trusting whatever would happen would be for the best. When I surrendered.

I found understanding the concept itself was not easy. Even after a lot of personal development, spiritual growth, energy healing, and life testing, I sometimes still struggle to let things be.

I have reflected on when I "surrendered" in my life - without labeling it as such, as I wasn't aware of the existence of this word until eleven years ago - and it taught me that I have had the most beautiful blessings when I stopped fighting and allowed things to come to me.

It has been a journey and I am still learning. I am sharing my most valuable lesson, the one I hope will resonate with you, in a bid to save some heartache, shed some insight and light, and offer a loving, helping hand.

DIVINE BALANCE

From a relationship perspective, I've always been a dreamer. I have been hurt, lost faith, and been wounded by others and myself because I was desperately looking for an ideal: a modern fairytale with a happily ever after.

Subconsciously, I wanted someone to love me, thinking it would provide the approval, normality, and recognition I needed to prove that I was worth something. I thought if someone loved me, then it would mean I was worthy of love and it would resolve all my internal battles and fears. I used to think that once I was with someone who was committed, I would be happy, find balance, be good. Does that strike a chord?

I was missing a crucial component here, though. Every relationship I was attracting was coming from despair, whereas it all starts

from within. In order to receive what is meant to be yours, you need to be in alignment with yourself by being in a Divine Energy. That sounds lovely, right? But what does it mean?

The Divine Feminine is the wholeness, the being, following your intuition, not overthinking, not judging. In a Divine Feminine Energy, you simply trust yourself and know your worth. It is self-acceptance, self-love, and self-confidence from a place of knowing that all is perfect and exactly as it should be. Not needing anything.

The Divine Masculine is the inspired actions coming from that place of perfection. As you are divinely guided and have all that is yours, you only take actions following your instincts, not from fear or lack but from love (self-love, self-acceptance, self-trust, inner knowing). The Divine Masculine Energy is the one that co-creates to elevate and be happier with no planning or strategy, just opening to whatever comes because it will be awesome and it feels right.

You can't go wrong when you are divinely guided as you listen to your inner voice, trust your gut feeling, and only act upon these energies.

It is identifying whatever the past has taught and triggered in you, and replacing it with a more conscious self no longer wounded. It is trusting yourself first by going within to discover and uncover the darkness and healing it so the true you can blossom. It is being perfect in the knowing that life will always bring you the experiences you need to grow and thrive and serve.

There was not one of my relationships prior to my now-husband that came from that place. I couldn't be alone, couldn't live on my own, couldn't face myself because I was scared of what I would find.

I had been brainwashed from a young age in the thinking that I was to be hated rather than loved. That not much was good in me and whatever I achieved wasn't good enough. I grew up in competition, fear, perception of lack. This is where it all goes wrong for most people.

What have you been told that you need to unlearn?

My mum hated my dad and used to tell me I was just like him from about the time I was five years old. She was always very prone to competition between my sister and me and used to emphasize how much better my sister was. She also repeated to everyone when I was a teenager that I was having a rather tough time physically and

my looks may come back afterwards. Another vivid memory of feeling terrible with regards to myself was when I was fourteen years old - my best friend told me I was ugly but that the world needs variety.

I remember as a nine-year-old being told by my teacher - the ultimate knowledge and authority - that I had no imagination whatsoever. I still remember the pain when she said that but I believed it to be true. It wasn't until nearly thirty years later, when the amazing man I now call my husband asked me to objectively take a look in the mirror, that I was able to realize by myself that I was one of the most creative people we both knew.

Life shouldn't be as you've been told. It's not about what someone thinks of you, however close they are. It is about what you think and want for yourself.

The balance between Divine Feminine and Divine Masculine is being in a self-loving place.

Understanding this is key to leading a happy, fulfilled life.

Before stumbling upon my amazing husband, I kept falling for the wrong people, thinking I was in love with them, convinced I could fix them, make them happier, and when I did, they would need me and stay with me. I thought a relationship would fix me, complete me, fill the emptiness. Most friends were living in their bubble with a loving partner, and I wondered why I wasn't worthy of the same love. I thought something was wrong with me.

There was nothing wrong with me except my behaviour and thinking. I was in a controlling, anticipating, overplanning mode, convinced I knew exactly what type of person I needed. I was acting upon a need to be with someone so I wouldn't be alone. Total wounded Masculine.

I was looking for someone to save me from myself. I was dreaming of an amazing relationship, yet incapable of being on my own, facing what was within. Total wounded Feminine.

So many people are in this pattern. The fear is not to be alone but to face the self.

Some of the best things happen when you least expect them, when you trust without overthinking and are peaceful from within. I used to really struggle with breakups. My lack of acceptance of a breakup, or any parting, was an incapacity to let go of something unfulfilling. I would spiral into judgement and self-blame while still being incapable of digging within and facing myself. I was afraid of

my darkness and what looking within would uncover.

The love, balance, support, and joy I sought in a relationship had to first be something given to myself in such abundance that sharing it with someone would be the result of the love I felt from within.

It is being in a place of divine balance, loving yourself, and being so whole and perfectly satisfied that you don't need a relationship to complete you. Then instinctively you feel like love would bring that energy of joy and happiness, because what elevates more than love?

In a divine balance, you know your worth and won't accept anything lower. That's when the magic of surrender happens: when the balance between loving the self and doing what makes you happy is in perfect alignment.

BREAKDOWN TO BREAKTHROUGH

Life forced me to give up, to give in. I went through one of the hardest breakups with my ex.

Not that it was a great story to start with, but I believe he was a lesson (and a great one) that led me to the happiest and most fulfilling relationship of my life.

I can see it that way now, but at the time I was incapable of taking a step back and reflecting. I thought no one would ever love me. I thought that what I had been told as a child was true and I wasn't loveable. That was the end of years of emptiness, failed relationships, and loneliness.

I hit rock bottom. Something had to change and I wasn't sure what or how. It took a great friend to point out the obvious: to be happy with someone else, I needed to find it within. She said I was a beautiful person. I'd never thought so. My self-esteem and self-confidence had been battered from a very young age.

Life was sending me mediocre guys because that's what I was putting out - average to negative feelings for myself - which in turn was further diminishing my self-worth!

I honestly remember this moment clearly. It made complete sense, it was pure logic. If I didn't love myself, how could anyone else? This was the breakthrough.

Was I self-sufficient, happy with myself, emanating joy, confidence, and gratitude? To be honest, I didn't even know who I was, but I was exhausted from trying and crying and at that point, I felt like

I had lost everything. I needed nothing and wanted nothing more. I gave up on looking, seeking, analysing, planning. I was feeling so empty that all I wanted was to survive and find some strength, and being on my own felt like a relief. I thought, if life brings no one into my life, it doesn't matter - I can have children on my own through insemination and give all my love to that innocent, perfect soul.

I surrendered, without realizing. I stopped fighting, I stopped needing, I stopped lacking, and thought that whatever will be will be.

My aim was no longer to fill the emptiness with an emptier relationship. It was to heal, nurture myself, do things that made me happy, plan trips with friends, define and get to know me.

This quote from Deepak Chopra resonates with how I felt:

"I UNDERSTOOD MYSELF ONLY AFTER I DESTROYED MYSELF. AND ONLY IN THE PROCESS OF FIXING MYSELF DID I KNOW WHO I REALLY WAS."

The only question to answer was, *Who am I?* I am a kind, loving, caring, generous person who shares all I can. I am intelligent, driven, hardworking, I would do anything for anyone I love, and likely even for someone I don't.

Without realizing it, I was healing my wounded Feminine. All that mattered to me was to see myself from my own eyes. One step at a time, I was on my way to a deeper realization of self-love and self-confidence, rebuilding from within.

Unlearning is the biggest piece of advice I can give. Be who you want to be. Don't believe what people say. It is their limitations, not yours, and their perception, judgement, and opinions. Every one of us can choose what we want for ourselves.

This quest for self-love should be the only battle we fight and the one we never give up on! Find inner peace and put yourself first. Give yourself that compassion, love, attention, joy, and anything else you value and that resonates with you. Feel whole, complete, happy with the self and be in that state of knowing that you are your best friend forever and your priority.

Once inner balance is found, all actions come from a place of love. Love for oneself and for enjoying the little things.

Having successfully found peace within, even though I was still

fragile, I started to go out again. For me, for fun. I was working with a few expats whom I wanted to introduce to the Paris of Parisians. I took a couple of them out on the town a few times, and my now-husband was one of them. When he asked me out, I thought he was everything I didn't need. He was not quite my type (if I had one), as he was the incarnation of kindness and, I thought, too sweet for me. In my mind, "we had no future" because his expat assignment was coming to an end within less than a year. I decided to give it a try just for fun!

I'm firmly convinced the Universe was trying to shake me to get in alignment and surrender so it could make its magic happen.

Three months later, we moved in together and have since made many happy memories in several countries, manufactured two perfect children who drive us insane together as a team, and have lived in nearly as many homes as the years we've been together. He is my partner, my best friend, he accepts my ups and downs, my craziness, my need to discover new places and experience new changes. He supports me through everything without fail. I remember us both being stunned by how perfect we thought we were for each other after just a few weeks of dating.

Eleven years later, we respect each other's individuality and independence. We've had our ups and downs, but every single time, we both thought **what will be will be** and as long as there is the slightest ounce of love, magic can unfold.

Surrendering doesn't bring what is needed or what is wanted or missing, it comes from a place of love and delivers beyond the wildest dreams. I never thought such perfection was possible. I never expected such magic, happiness, and fulfillment. Letting go of what I thought I needed or wanted led me to love.

Every time I let go of the outcome and thought what will be will be, a dream came true, or turned out even better than I'd hoped for.

When one co-creates, it's all about finding what the intuition is whispering and following it through, knowing that it is a guided action of love. As wild as what you hear from your intuition may be, trust it. Don't settle. Visualize, hold that vision, have fun, take action from that energy of joy, and feel good doing it!

All events are neutral, it's the perception that makes them positive or negative. By perceiving everything as a positive and an opportunity to grow, we allow alignment. You have everything you need right now. Feel those words, let them vibrate. You are whole, divine, per-

fect as you are. Let the darkness unfold, let go of resisting, and think of it as moving sands, which resistance just makes more painful. Know that whatever is actioned from that place of freedom will be divinely guided to provide what is destined to be yours beyond expectations.

My surrendering is acknowledging all things with love, grace, and gratitude, trusting that the best is yet to come.

ACKNOWLEDGMENT

I WOULD LIKE TO THANK MY HUSBAND GAVIN, MY FAMILY AND FRIENDS FOR THEIR LOVE AND SUPPORT, AND CASSIE FOR ALLOWING THIS DREAM TO COME TRUE.

4

INTUITIVE
AWAKENING

*"Be the Love you
wish to feel in your life."*

BY: CORYN PAWLIW

CORYN PAWLIW

CORYN PAWLIW

Coryn grew up on the west coast of Canada in Nanaimo, British Columbia. As a young girl, she had a fire inside of her, a calling to be more and do more in the world. She's always had a deep sense of compassion for helping people, and has been a leader since a young age. She always wanted to teach and inspire others.

When Coryn was pregnant with her daughter eight years ago, things shifted for her. She went through a transformational process in which she decided that she was ready to ignite that fire within and unveil the deep self-love she knew existed within her soul.

Coryn is a Reiki Master, a Medical Intuitive, and a Spiritual Life Coach. She travels across Canada teaching workshops on empowerment, belief re-patterning, and Reiki.

Coryn has an ability to inspire and lead others with a sense of ease and confidence. People feel calmness in her presence, unconditional love, and acceptance. She leads with love and lives her truth in all she does. She believes that every person has intuitive gifts, and it's her calling to help them step into their desired life.

www.corynpawliw.com | coryn@corynpawliw.com
fb: @coryn.pawliw | @cnpawliw
ig: @coryn_pawliw
#bethelove

SELF-LOVE IS THE FOUNDATION OF LIFE. You have to love yourself before you can love someone else. We are taught that love comes from things outside of us, that we need outside validation to be loved and accepted. This ultimately creates empty space within our hearts that we attempt to fill and can take a lifetime to reprogram. My passion, my calling, is to help guide you home to yourself. I take people deep into the layers within and help them shed the limiting beliefs that keep them stuck in their lives, to awaken their journey to live a desired life of passion, purpose, and soul.

I always knew in my heart I had a message to bring to the world. There was a voice that kept speaking to me until I finally heard it. I had an ability to lead and inspire people from a young age. It has been through my healing experiences that I share my knowledge, my vulnerability, and my wisdom. It was through sinking into the core of my being and aligning with my soul that I found the missing pieces in my life. I craved living in a connected space with flow and ease, filled with joy and beauty. I wanted deeper connections with people, and I craved love at the depth I knew existed. I wanted to emanate an energy that magnetized more love and abundance into my life.

The journey to self-love has been, and continues to be, one of depth, surrender, and forgiveness. There is no destination; once we learn this, the journey becomes one of ease, flow, and beauty. Even through the most chaotic parts, I found inner peace once I surrendered into the process of loving myself.

I always knew as a child that there was something bigger for me. I felt it deep within me, I had glimpses of it, but could never figure out what my purpose was. What I did know was that I was always the one who could see love in everything and everyone.

That longing to be more - I wanted it so badly. I studied all the self-help books but never felt the depth of what I thought I should be feeling. My problem was exactly that - trying to figure it out. I was the Control Queen and wanted everything to make logical sense, but I was numb. I was in my head, not in my heart. I realized I hadn't truly felt anything in years.

Do you feel you have everything you should, but there is still something missing? A deep longing for passion? For the soul connection you've dreamed about since you were a young child? Is there an empty space in your heart? Do you know there is more but don't

know how to attain it? You know it exists, but you can't figure out how to get past all of the junk that's in the way. We come into life born as love and along the way we inherit baggage and beliefs. The emotional trauma, the blame, the guilt, the shame, the anger all block our true happiness. Maybe you want to start your journey to the deepest self-love possible, but you have no idea where to begin. It might feel scary and, if you feel anything like I did, alone.

Almost eight years ago, while pregnant with our daughter Kaila, I experienced a painful day - one that changed my life forever. I sat on the floor of our basement in a puddle of tears. Alone, depressed, and hopeless, I wasn't sure if I wanted to go on.

Here I was, carrying the seed of life within me, and I was far from elated. I hated myself, I couldn't look in the mirror and say one positive thing about myself. I don't know how I got to that place. Growing up, I was a confident girl, so to be in this place of unknowingness felt heavy. Laying on the floor, I saw a box of Rainforest CDs. I took one of them and plugged it into the CD player. I sat in quiet listening to the music that came through the speakers, and that was the day everything changed for me. I didn't want to fake who I was anymore.

In that moment, I made a commitment to myself that I would change my beliefs. I would learn to love myself, as I couldn't bear the thought of bringing a child into this world feeling the way I felt. The journey has had me hit my knees more than once, face-to-face with my deepest fears.

There was so much inside of me that was screaming to become free, to share who I was from the depth of my heart. I wanted deep, meaningful connections that would raise my vibration, I wanted to learn how to meditate, and I wanted to be the love I felt deep within my soul. I knew it was possible. For years, I resisted so much of who I was, and that was my unhappiness. I had succumbed to the world's way of thinking, I had crammed myself into a box, and I didn't fit into a box. I was living in fear - the fear of what if? I had shut down the creative fire that resided within me.

I had to learn to forgive. I had done a lot of self-development work over the years and I thought I had forgiven, but the truth of forgiveness comes through the process of surrender. I had to learn to let go. This was not easy for a woman who had to have control over everything. I had to open my heart and allow the control I thought I had to dissipate, and to let go of expectations. All of the hurt and

blame I had inside had to be healed and released.

Day by day, sometimes minute by minute, I learned to be present. I created awareness in everything I did. I learned the power of now.

I changed the way I viewed things. The late Dr. Wayne Dyer used to say,

"IF YOU CHANGE THE WAY YOU LOOK AT THINGS, THE THINGS YOU LOOK AT CHANGE."

This became my mantra. Each morning, I started with gratitude for the simple things. I saw everything in my life as a miracle - each person, experience, and event had impacted me in a way that had helped me grow into the strong, resilient woman I was.

I learned to love all the people in my life I felt had wronged me, and I surrendered into the feelings that were there. The hurt, the anger, the sadness - I had to allow all of those feelings to be felt at a depth I never had. It was challenging - I didn't want to go back into the events and experience the hurt I had felt so deeply in my past. Have you ever been so afraid to revisit your past that instead you do nothing? The very thought of the pain feels unbearable, doesn't it? That was where I was. I was playing my victim card. We all have it, the key is in how we choose to take the experiences and bring forth the miracles.

I learned that the events were just experiences I created the feelings from. I created the beliefs. I had to let the feelings come through and allow my body to experience them to release them. I had to let the anger be there to allow myself to feel again. Most people push away feelings that are not positive, but the truth is that we are human, we have emotions, and when we learn how to feel them and release them, a profound healing occurs within the body and mind.

Once I worked through the feelings, I saw things in a new light. The people I had the feelings about felt different to me. There was true forgiveness - a lightness I had never experienced before. I hadn't even tried to forgive, but the process of being with my emotions and releasing them allowed my soul to forgive. Some of this work came through as writing letters and burning them, but most was done at an energetic level - no physical conversation happened, it was all through meditation and prayer work. I would have conversations

with the people about whom I wanted to heal my feelings, and it worked. This led me deeper into meditation practice, where I let go of deep-seated wounds that had created so much fear in my life. My practice became longer as I let go of more. I felt a sense of love and light that emanated from within me. I was able to see the light within someone, to see past the shadow parts of them, and this allowed me to heal the places inside of me, which started a ripple effect in my life. People around me started to transform their own lives.

I saw where I needed to set boundaries in my life - where I had allowed people to overstep my boundaries, which created resentment inside of me. I honored myself and said no to things that didn't feel right for me. It wasn't easy at first but once I got used to it, it felt freeing to follow my intuition. I realized I had been living the values of others, not my own. This was a milestone for me, learning what my values were and honoring how I wanted to live my life, creating space to feel connected. When I sank into my values, this shifted everything in my life. Each morning I began with meditation - it started with just five minutes before the kids awoke and grew into a two-hour process each day.

What would it feel like to embrace that light, to embrace your intuition all the time, and to live by it? To have access to it all the time? It's possible. You have the ability to tap into your soul and live an inspired, passionate life that feels aligned.

There are only two emotions in the human realm, fear and love. Everything else stems from one of those emotions. We have to get to the core roots of our beliefs (fears) in order to change them. We need to bust them open, go face-to-face with them, and surrender into the suppressed emotion that lays dormant in our physical body. When I started the deep emotional work, I released physical pain that had kept me immobilized for years. I released excess weight with ease and my mind became clear. The fog lifted. I was guided to do things that felt aligned, serving in a bigger capacity and helping others heal. I designed new values that served me, that honored my heart, my soul, and my purpose.

Each of us has something within us that only we are destined to share with the world. Our collective fears hold us back from aligning

with that calling. We are all meant to step into a higher paradigm of service. To realize it's about more than just ourselves. We come from a collective consciousness and when we serve from our highest good, our intended purpose, we raise the vibration collectively, inspiring others to do the same. A ripple effect of high vibration.

I discovered my calling through my own healing. I had the gifts all along, but I had to first heal myself in order to learn that I had the ability to help others heal and spread love. That's all we are: love.

Each of us has the gift to heal, it's all in different ways. One of mine is through my hands and my body - I move and shift energy, I can see and sense energy (auras), and feel where mass is accumulated and stagnant. I have an ability to see through to the core of people, beyond the masks they wear. I see their light, their darkness, and what they are capable of achieving beyond their fears.

Through the surrender into myself and my healing journey, my gifts were brought to life. I've had incredible mentors along the way who have been by my side. My coach Ryan has been instrumental in guiding me, and I'm forever grateful for the connection we have.

I've been blessed with great teachers all around me my whole life - all I had to do was sink into receiving. I resisted people for a long time, resisted love, especially receiving love. I was great at giving love, but I had to learn to love myself so I could receive it. Some of my greatest teachers are my parents, whom I rebelled against for a long time. I held resentment and anger, sadness and pain. Once I learned to let these emotions go, I forgave them and can now see them as my biggest teachers. My love for my parents runs deep. I am grateful I chose them as my parents and that they support me in all I do. They are the lights in my life that have been guiding me all along.

Finding gratitude in our lessons is the foundation of building a life of self-love. That's the miracle - shifting from fear to love. I learned to love every moment of my life for what it is. To be present in each moment. To find the love and miracle in every experience and every person I have the blessing to encounter.

Finding the way back home to ourselves is a journey - a lifelong, beautiful journey - and through the challenges, we find the gifts.

Through our mess, we share our message. By learning to love ourselves unconditionally, we love others. That's how we heal the world, through a collective shift into surrender, forgiveness, and love. We are all sacred beings.

One of my favorite quotes from a Lee Ann Womack song reminds me to remain humble and to rise up. It's also the song that reminds me of one of the greatest teachers in my life, my Nana, whose hand I had the honor of holding while she made her transition from the physical earth into the Spiritual realm.

"I hope you never fear those mountains in the distance
Never settle for the path of least resistance
Livin' might mean takin' chances but they're worth takin'
Lovin' might be a mistake but it's worth makin'
Don't let some hell-bent heart leave you bitter
When you come close to sellin' out reconsider
Give the heavens above more than just a passing glance
And when you get the choice to sit it out or dance
I hope you dance, I hope you dance
I hope you dance, I hope you dance"

I hope you dance, I hope you find the courage within to face your fears, to climb the mountain in front of you, knowing it holds the greatest lessons and gifts for you.

We need to be open to hear the voice that's within, drop into our hearts and feel, and allow our souls to lead. Be open to opportunity and know not all the beauty in life comes in the form we expect - our logical mind creates illusions and fears. Heal ourselves and we create a profound ripple effect in our lives and beyond. We change the world through our own healing and then offer our hand to others.

When we change the way we look at our life, we will transform the life we live.

Be the Love.

ACKNOWLEDGMENT

I WANT TO THANK EVERY PERSON WHO HAS COME INTO MY LIFE, ENRICHING IT WITH THE LESSONS AND GIFTS FOR MY SOUL JOURNEY. TO ALL OF MY FAMILY, FRIENDS, MY CLIENTS, AND MY COACH RYAN FOR SUPPORTING ME AND BEING WITH ME ON THIS JOURNEY TO AWAKEN MY CALLING WITHIN.

5

CHASE THE DREAM, NOT THE MONEY

"Sometimes the process is messy, that's okay, we aren't meant to be perfect."

BY: KÍRSTEN STUCKENBERG

KRISTIN STUCKENBERG

KIRSTEN STUCKENBERG

Kirsten Stuckenberg is a soulful, multi-passionate entrepreneur and author. She inspires others to live a soul-aligned life and follow their true north. Kirsten left the fast-paced auction industry after ten years to pursue her dream of a freedom-based lifestyle and ditch the boss for good. She broke into the Real Estate industry and found that she was able to pursue her passions and live life on her terms. Never looking back, she discovered that life is meant to be passionate and joyful. When she is not shaking up the business world, you can find her horseback riding and enjoying life outdoors. Raised on Vancouver Island, British Columbia, Canada, she feels grounded and inspired when she is deep diving in nature and near water.

fb: @KirstenStuckenberg
ig: @kstuckenberg

HER ART OF SURRENDER

HAD BEEN IN AN uphill battle for years! Grinding to get where I was going! Lost and unrecognizable, even to myself, and not sure I knew my way back. There is a saying, "It's okay if you're not sure where you're going, your soul knows the way." Well, I hadn't listened to my soul in years. In fact, at this point, I thought my soul had died and left an empty, unsupervised body to function through life. So now what? Well, I'd be lying if I said that I didn't have a breakdown. I could have given in to the feeling and stayed in that state of mind, but something inside me knew better. I followed the crumbs the Universe left out for me and gave in to the process of life happening *for* me. You're probably wondering what that even means or how to start doing it for yourself, so let me take you through my journey of surrender.

I was putting everything I had into my job and my side endeavors and, at the end of the day, I was left unfulfilled and my soul was drained. At a certain time in my life, this was exactly what I had wanted - I had made it through my checklist: I went to college, had a career, got married, bought a house, obtained multiple streams of income, and adopted as many fur-babies as possible. And yet I woke up wanting to pull the covers back over my head and hide from life. I was not happy and I couldn't ignore it anymore. My job was draining, which made me unhappy in my personal life, or vice versa, and before long there, was no divide between what areas I was or was not happy with. This was followed by a scary situation with my health where I no longer had control over the outcome. I became sick, was hospitalized, and was later diagnosed with a potentially life-threatening disease. Somehow I knew within my soul when this happened that it was the way of the Universe yelling, "STOP! We're not going any further down this path!" Now I had tough choices to make. My doctor told me to cut stress out of my life and take better care of myself and my body. I knew it was time to leave my job that was killing my soul. This news should have been devastating, as I had been there for eight years and given it everything I had, but it turned out to be the best thing that ever happened for me. It got me back on track to finding my true purpose and passion in life. At first it was hard to not wake up and go to work everyday because I felt lazy, but it turned out the reason why I was so busy prior to this incident was that I didn't want to be alone with myself. I didn't like the person I had become - I no longer recognized myself and what I was in the mirror didn't resonate with me anymore. Over the previous five years, I'd been working twelve hours a

day, without major time off, thinking I was getting ahead in life. After laying in a hospital bed, I realized that everyone's definition of success is different. I had been assuming I needed to be busy twelve hours a day, that I had to be making a certain amount of money, and that I needed to have all the cool "stuff" to show off. Whose idea of success was I living up to? Where did this standard come from? Why did I put this much pressure on myself? At the end of this torture I had unconsciously put myself through, I realized that if you are not living the life of your dreams, a life that sets your soul on fire with passion, you are robbing yourself. Somehow I had allowed other people to rob me of that joy for years and my happiness was determined by the size of my paycheck for far too long. Focusing on completing my checklist, I forgot to add core desired feelings of fulfillment, purpose, and love in there. I would lay awake at night thinking, *What's next? What is my next project to distract me from the fact that I am not happy with my life?* Always feeling like I wasn't good enough and didn't deserve to be happy and loved. Suddenly I was having this massive shift that gave me no choice but to change my thought process and I realized that what matters in life is connection, people, loving and being loved, and letting things happen *for you* not to you. Finally learning how to love myself and my people more than I ever thought possible, a part of my heart cracked open that I didn't even know existed. All the things that used to be important now seemed very insignificant. This got me thinking about how I could help people, make an impact, and find my purpose in life. Life is so short, and I was wasting it on completing the checklist that society made me believe was important. I needed a break, I needed to heal myself and feel happy again.

What happens next...? All I have to say is INTUITION! Use it and trust it! This has been the most humbling experience of my life because you can't control it, you can only access it - *there is a huge difference.* Once I accepted this and leaned in to the process, the more magical my life became. The less pressure I put on *making* things happen, the more things were happening *for me.* I was being put together with like-minded people without effort, and I was being offered opportunities that lit me up and got me excited. I was being led into the life I had always desired and I wasn't trying to make it happen! How is it possible that by doing nothing - and what I mean by that is not forcing every event in my life to happen on schedule - everything seemed to be happening? I gave in to the process wholeheartedly!

I'm not going to lie, it was scary to relinquish control and let the Universe guide me. Almost every person in my life told me I was crazy, but I soon realized those were not my people. How had I spent this much time with people who were not meant for me? I will tell you it's because *I was not awake!* Everyone told me I was making a huge mistake giving up my secure job and steady paycheck. I had no idea what I was doing but I knew there was more to life than working to pay bills and then die. I turned up the volume on my energy and intuition and doing this led me to the right people. The saying, "Your vibe attracts your tribe!" is true. These were people who understood me, who gave me direction, support, wisdom, and love. I could actually make money doing things that made me happy and I didn't have to grind to be successful - or perhaps my definition of success was changing? I realized that being surrounded by people who love you and have your best interests at heart is in fact a version of success. The more I developed my intuition, the more confident I felt using it and talking about it, which is something that used to scare me because I thought people would think I was crazy. As it turns out, when you are surrounded by the right people, nothing you say sounds crazy because they accept you for who you are. Feeling better physically, I noticed that the more I pushed away things not meant for me, the more my body healed itself. No longer stressed, run down, and haggard, I was actually sleeping at night instead of tossing and turning. My doctor agreed I was getting healthier. Not realizing it at the time, I'd almost killed myself with the stress of living a life that wasn't meant for me. I was told by a friend that a good motto for living a soul-aligned life is to ask yourself one thing in all situations, "Is this light and easy?" At the time I was thinking, *Well sometimes you gotta do what you gotta do,* but the more I let what my friend said resonate, the more truth I found in it. Light and easy, what a wonderful way to live and appreciate life! Why do we put this pressure on ourselves to live a life that isn't meant for us? To stay in relationships that no longer serve us? To complete the checklist of societal pressure? What are we scared to experience and feel? For myself, I was scared to put myself out there for fear of people not liking me and not accepting me for who I really am. I was also afraid of failure, but I have learned that fear is actually a good thing. When you fail (which is just the first attempt at learning), you have at least tried for something and you can be proud of that. People may not understand me, or my journey, but I'm okay with that.

I am no longer attached to the outcome - I have learned to let it go.

My experience with surrender hasn't been an easy one. I had to learn to quiet my inner critic, to shut down my ego when it tells me I'm not good enough. To let things flow and play out the way the Universe intended. In the past, I always wanted to know where I was going in life, what vessel would get me there, how much money I would make, and what it would look like when I arrived. Now I realize that by letting go, relinquishing control, and surrendering into the process, I get surprises along the way and that's part of living rather than simply existing. You don't necessarily know where the path is going to take you, but it's the journey that shapes you into the amazing person you're meant to be. You will meet people along the way meant to be teachers for the person you're trying to become, and you must accept them in the form they show up in to learn the lessons. Sometimes the process is messy and that's okay - we aren't meant to be perfect. If there is any advice I can give, it's to love the journey, not the destination. Learn the difference between happiness and pleasure and chase after the right one (happiness). Set out on the life you were meant to live. Don't be afraid to be yourself - the world needs more of that! Your intuition is key to everything you're doing in life. It will never steer you wrong if you listen to it and that is the truest form of surrender.

ACKNOWLEDGMENT

I WOULD LIKE TO THANK EVERYONE WHO HAS HELPED DEVELOP ME INTO THE WOMAN I AM TODAY. I AM FOREVER GRATEFUL FOR THE INCREDIBLE MENTORS I'VE BEEN SO FORTUNATE TO HAVE.

6

I AM WORTHY

"Inhale love. Exhale love. Be love."

BY: CHARLEYNE OULTON

CHARLEYNE OULTON

CHARLEYNE OULTON

Charleyne Oulton is a confident, happy, and divorced stay-at-home mom of three children who lives on beautiful Vancouver Island, BC. She is genuine, experienced, and passionate about creating and maintaining a life full of peace and joy. She is also an appreciated health and wellness coach, author, and photographer, even through the busy and beautiful chaos of raising a family. It is her purpose to inspire women, and specifically the busy, overworked, and exhausted mothers around the world, to remember their personal strength. That they, along with us all, are deserving of living a life filled with health, happiness, and harmony.

www.coachcharleybrown.com
fb: coachcharleybrown
ig: coach.charley.brown

I AM WORTHY. THESE THREE little words hold so much power, and have become part of my daily affirmations and meditations. These words have given me strength when I have felt weak, given me hope when I have felt desperate, and have inspired me to constantly remain laser-focused on my personal growth and healing. There are certain moments in life in which one must completely surrender their expectations and selves to allow the natural way of things to happen and unfold. Moments where you need to believe in yourself with all that you are, and realize that perhaps it is time to stop fighting fate.

I will never forget the exact moment my marriage ended. It was about 10:00 p.m., my children were sound asleep, the house was clean, school lunches packed, and I was lying in bed, alone. This was a common occurrence throughout my marriage. I received a text message from my husband stating that he "no longer wanted to be married." I choose not to go into further details about our conversation or the details of our marriage out of respect for our children, him, and myself. But I can say this, if it were possible to feel every emotion at once, that is how I would describe how I felt in that moment. I sat there for a while, waiting for the tears, argument, and hostility to come, and was surprised when they did not. After a few deep breaths, I told myself over and over again, "What is meant to be will be."

"DON'T BE TOO QUICK TO INTERRUPT THE MOMENT. JUST KEEP QUIET. MY ENCOURAGEMENT WOULD ALWAYS BE: NEVER THINK ANYTHING IS AGAINST YOU, EVERYTHING IS A BLESSING. WHY SHOULD IT BE DIFFERENT? JUST BE QUIET, LET IT ALL WORK ITSELF OUT." - MOOJI

Everything comes to you in the right moment. Be patient. Be grateful. Believe in destiny and fate, and that "What is meant to be will be." The easiest way to create and live a fulfilled and happy life is to become a master at "going with the flow," and to do what is right for you right now. But I also know how hard these practices can be. Change can feel terrifying. Being courageous for yourself is not always the easy choice. Doing what is right for you can sometimes feel impossible and unattainable. But your ultimate happiness is worth fighting for, and so is your joy. Joy is HOPE. Joy is always within you.

TODAY IS A GOOD DAY TO START WALKING AWAY FROM ANYONE OR ANYTHING THAT CAUSES YOU MORE ANGST THAN JOY.

Divorc, Divorci, Divorce, Divorzio, Divorcio… No matter the language, I do not like this word. I think it's ugly, and it makes me feel bad about myself. I never envisioned myself as a divorced mother of three. Even though my marriage was toxic for my soul, and often left me feeling both drained and depleted, I would not have wished divorce for us, or for our children. Yet I have learned through divorce that sometimes in life, we must allow change to happen, surrender our expectations, and accept our current situation. I was stuck in a day-to-day routine that was not fulfilling my needs or fully meeting my deepest desires - I was lying to myself every single day. I had settled and accepted my role as a wife and mother and nothing more. I'd taught myself to see the good and appreciate **only** those moments. The truth was that I was not happy, and those who knew me knew it. Even though I put on the apron, the smile, and the appearance of a happily married housewife, my soul craved more. I knew I was capable of it, but I refused to listen to my gut, or admit this aloud out of fear.

This was what all wives go through, right? This is what marriage feels like, right? Isn't it supposed to be hard, and isn't this "hard" what is best for our children? These are some of the lies I convinced myself to believe. I was in a relationship with the same man from age 16 to 30, I had taken a vow, and this was my life and future, so I better make the best of it. So I thought.

But as he packed up his things and left that night, I let him. I vowed to be strong for myself and for our children. And I was. I pulled out my note pad and I wrote a list. A bucket list, so to speak. A list of things that I wanted and needed to accomplish in this lifetime - just for myself. A list of the pros and cons of us divorcing, and my goals for our children. With my pen, I drew a mind map of assets and debts, trying to make a plan for my new future, and then I dropped to my knees and prayed to my God. Desperate prayers for strength, fair resolution, and no conflict. (Little did I know that it would take a grueling

444 days to get any resolution. I later learned that in numerology, 444 means directional. It means you are headed in the right direction!) I meditated and surrendered to my heartache, crumbled, and dove into fear-driven puddles of tears. Allowing myself to feel, and cry and cry, until finally there were no more tears. Then I slept. It was the first time I'd truly slept in months.

"BE CRUMBLED. SO WILD FLOWERS WILL COME UP WHERE YOU ARE. YOU HAVE BEEN STONY TOO MANY YEARS. TRY SOMETHING DIFFERENT. SURRENDER." - RUMI

Sometimes you must fight for what you believe to be true and right for you, and sometimes you must surrender to what actually is. Both can be equally challenging and difficult. I chose the latter. To be true to myself for the first time in my adult life. To surrender my worries and fears, the judgment of society, and my desire to control, and to become a priority in my own life. The opportunity to start over and live a life filled with joy was starting to feel achievable. This was my chance to love myself and start fresh. It is terrifying to be sitting there, wondering what your future looks like, questioning your ability to handle the unknown and unwanted stress, and all the emotions and anxieties that can circle around these thoughts. I have cried and questioned, almost daily, if everything will be okay. But I made a conscious decision to do whatever possible to turn this chaos and nightmare into a blessing and bright future for myself, and for my children.

This is when your support network becomes important. Reach out and ask for guidance and love from friends, neighbors, family members, and even others who have gone through something similar. Learn from their experience and mistakes. This was my time to be courageous and chase my wildest dreams. I started seeing a counselor who helped me learn to cope with the emotions, heartache, and unknowns that come with a divorce. I took parenting courses and read so many books. I started journaling every single day and I practiced manifestation. This was an opportunity for me to grow, and it can be for you as well. I still have moments when I find myself filled with anxiety, fears, and doubts. When I feel this way, I take a few

moments to breathe and remember my why. I am a mother, and my children and myself are my why. My children give me strength and courage, and when I think of them, I remember that I am one of the most important humans in their world. They look to me for advice, encouragement, stability, and to be a role model. This is no time to be weak. I practice Power Stancing and I remind myself that I am important, capable, worthy, and strong. If I can push through these moments of uncertainty, then you can, too. **You can!** I believe this fully. You only need to make a decision and commit to it.

I want to give you the purest, most sincere, and genuine advice I have been given – always, always, always listen to your gut and follow your heart. Those goosebumps and chills you sometimes feel and that little voice inside your head are all trying to tell you something. Pay attention. I used to fear divorce, being alone, dating, and the judgement of what my family and society would think of my failed marriage. I used to ignore all the warning signs and red flags. This was the life I thought I wanted. To me, the "D" word was the ultimate failure. Even though I was married to the wrong person, I had accepted the role as a wife and I tried very hard to fully find true happiness. The problem was, I was looking in the wrong place. Happiness and joy come from within. I deserve to be a priority in my life. Once I remembered this, I was no longer as fearful of the change that was ultimately happening.

It is an incredible experience to be stripped of everything you thought defined you. Your title, role, possessions, career, family, vehicles, bank accounts. My entire world was shifting right in front of me, and so much of it was out of my control. I learned very quickly that I must become a master at maintaining balance, managing stress, and simplifying my life. My house, belongings, time with my children, assets, debts were all being divided. I learned to be grateful and find joy in the simple things - time with my family and friends, the sound of laughter, gardening, cooking, and enjoying a meal with my children. My pets, a book, music, writing, photography. I was shocked to find that I loved rediscovering all my passions and that these massive changes in my life were actually wonderful for my soul. Although it took much courage and I shed many tears, I was beginning to heal and find my voice and path. I needed to remember to allow myself to cry and freely express any emotion I felt, whenever I felt compelled

to. I have experienced everything from pure fear and worry to absolute joy and freedom in my divorce. I surround myself with happy thoughts, and people, and things that make me smile, yet still allow myself the chance to cry when needed. This is my chance to create new patterns and habits. To create my future.

THAT IS THE THING WITH DIVORCE, YOU GO FROM WE TO ME.

George Elliot says, "It's never too late to become all that you might have been." This fully resonates with me and I have taken this abrupt life change as an opportunity to grow and heal and become who I was always meant to be. So I encourage you to close your eyes, take a long deep breath (or as many as you need until you come back to the strength within), and repeat after me: "Every single day, in every single way, I'm getting stronger and stronger and moving closer and closer to my goal of happiness, health, and harmony." Please remember that YOU are capable of amazing things.

MY DIVORCE WAS HARD BUT ALSO THE BEST THING THAT EVER HAPPENED TO ME.

What I have come to realize through my experiences is that life and your heart can be filled with so much more if you only open up to new adventures, experiences, and life paths. The author Neale Walsch says, "Life begins at the end of your comfort zone," and this is exactly what I needed to believe and practice. To fight for my own health and happiness and break out of my pattern of being in survival mode and staying in a relationship that I knew was not right for me. I needed to allow my husband to go, because I felt that we were holding each other back. I always knew this to be true, but I forbid myself to accept it. A good friend of mine reminded me that the end of our relationship might just be the best thing that could ever happen to me. I didn't see that then, but I see that now. I can honestly say I have no regrets. Valuable lessons were learned, I experienced high highs and low lows. Life happened - the good, the bad, and the ugly. I survived it all, and am grateful for this journey, even though it was not always easy. I am proud of myself. I am continually growing as an

individual. Putting myself out there. I started dating and met a wonderful and honorable man. Someone who loves me and my children deeply. I have never felt this joy, love, support, or friendship before. *Is this what true love feels like? Why didn't anybody tell me?* I think I needed to fall in love with the wrong person. I learned so much about myself and about love. Lesson after lesson taught me to find strength, to fight for what I know to be true, and to always have faith and hope in my heart. Thankfully, that man is no longer a part of my love life and I feel empowered and respected in my new relationship. I truly feel I have found my soulmate, and if it were not for my divorce, I would have never met him, nor appreciated just how wonderful he is.

We all need something different from life and have a different path to walk. Sometimes we need to do what scares us the most, or do what is hard. Sometimes you need to follow your gut or intuition, or go against your family or religious beliefs. I encourage you to keep an open heart, remain positive, and trust life's journey. Stop being a worrier and start being a warrior!

ABOVE ALL ELSE, YOU NEED TO DO WHAT IS RIGHT FOR YOU.

Much Love,
Charleyne Oulton

ACKNOWLEDGMENT

ENDLESS HUGS AND KISSES TO MY FAMILY, FRIENDS, AND FIANCE, WHO HAVE LOVED ME UNCONDITIONALLY AS I STUMBLED THROUGH THE CHAOS THAT IS DIVORCE

⑦

LETTING MOTHERHOOD HAPPEN

"When I looked toward my future, I just saw black - my predictable path was gone."

BY: NICOLE MARTIN

NICOLE MARTIN

NICOLE MARTIN

Nicole Martin is a Mindfulness Coach whose purpose is to support others in their quest to be their own North Star and live a life that lights them up! She is certified in somatic coaching techniques, meaning the whole person - mind, body, and spirit - is taken into consideration. She has successfully guided clients through job searches, career shifts, divorce, time management challenges, and much more.

Combined with a keen business sense from fourteen years in corporate human resources and an MBA from NYU, Nicole's style is a beautiful balance of analytics and intuition. After achieving what could have been viewed as a "perfect" life, Nicole had an awakening and realized how unhappy she was. The result was not the dramatic Hollywood comeback story we're used to, but rather a conscious exploration of self, followed by deliberate lifestyle changes and mindset shifts to put her back on the path she was meant to be on all along.

Nicole lives in New Jersey with her husband Ryan, daughter Teagan, and rescue dog Hogan. Outside of coaching, writing, and organizing the chaos under her roof, she likes to relax through yoga, hiking, and sipping craft brews - both beer and her tasty batches of homemade kombucha. She lives each day as presently as possible and will continue to overuse the phrase, "Everything happens for a reason."

When Nicole isn't practicing being present,
you can find her online here:

fb: @wellandguided
ig: @wellandguidedlife

I **AM A PERSONAL DEVELOPMENT** coach who is passionate about teaching working moms how to make conscious, empowered decisions for their family, career, and most importantly - themselves. But before I could coach moms, I had to become one myself. In this chapter, you will find the story of how I became a mom - but let me say upfront, if you were expecting a steamy romance, you are in the wrong place! My journey toward motherhood was a difficult one, but I would not ask for anything different. This was the time in my life when I learned that logic and reason do not resolve all of life's problems.

To know me better, let's go back to my childhood. I was a well behaved kid and I was also shy. I never wanted to disappoint my parents, and listening to my teachers was even more important because getting called out meant public humiliation. My stomach starts knotting up just thinking about it! So I became complacent and followed the status quo, as this meant I would not call attention to myself or look different from anyone else.

Not only was I a people-pleaser, but I also put my full trust into the lessons my parents taught me. I was raised to think in black and white, and to take a more conservative approach to life. This is what I knew, and for most of my life, I trusted that playing by the rules would ensure my success in all that I did. I was also expected to earn good grades, get into college on a scholarship, study a subject in which I knew I could get a well-paying job, and then go out and get that job. I did all of this, and as I checked all the boxes on this list, I received validation that I was living life correctly. This made me feel amazingly successful! The praise from parents and teachers, admiration from my younger siblings, ability to proudly list my accomplishments, all helped me live up to society's status quo and ensured I was not going off course.

This way of living also made me feel secure because I naively thought I had it all figured out: I had a formula I followed, it worked, and it guaranteed my comfort. My life's path appeared to be clearly laid out for me. What I could not foresee were clouds so thick and threatening that no formula would push me past the storm. My life was about to go from reliable to unpredictable turmoil.

As I grew up, and even into my early adulthood, if something didn't go right, I assumed it was because I'd made a mistake, so I would analyze every detail to determine how I should move forward out of that cloudy period. I also planned my future this way, which was

sure to be bright and sunny! All I had to do was continue to advance my career with a healthy dose of work/life balance, marry my boyfriend, Ryan, save money and buy a house, and when we were ready, we would start a family. Sounds amazing, right?

The part about all of this that worried me the least was the family aspect. I knew from high school health class it was easy to get pregnant and I could take birth control to ensure there were no unplanned pregnancies. In the meantime, I took care of my body by eating well and exercising several times a week. I had no reason to believe I couldn't plan my way towards having kids. It would just be another box to check off of my perfectly laid out life plan. As we entered our thirties, Ryan and I talked more about kids and when to have them. Being so logical, we agreed to first take a bucket list trip to Peru and start our family after that.

We booked our Peru trek, which was now a huge milestone in my mind. Ryan and I were thirty-two and, being married four years, people often asked when children would come into the picture. Our closest friends knew that we had "pulled the goalie," so to speak, but overall we kept our plans quiet. While I was okay with those closest to us knowing we wanted to start a family, I was really bothered by questions from family, coworkers, acquaintances, even perfect strangers, because I felt like we were being judged against the "norm." Though I had been living my life up to the status quo, I believe families come in different shapes, sizes, colors, etc. If Ryan and I felt like our family was complete with just the two of us, then there was nothing wrong with that.

Knowing our personal plans, I would glow on the inside with joyful anticipation. I would fantasize about breaking the happy news to our family and friends, and how excited our parents would be to become grandparents! One friend joked that if we conceived while in Peru, our kid might come out playing the pan flute. While I laughed at the absurd image, I also attached myself to getting pregnant while on this amazing trip, and having the rest of my life fall right into place as it should.

As I researched pregnancy and labor (always be prepared!), I decided to have as holistic a birth as possible. I'm not someone who automatically turns to medicine when I'm sick, so the thought of an unmedicated birth resonated with me. Women gave birth without epidurals for centuries - evolution was on my side. So getting preg-

nant would also mark the time when I would turn towards an all-organic diet with only safe holistic remedies as needed. I was all in and every time I thought about my plan, the sun shined brighter.

TRUST YOUR INTUITION

As we planned our trip to Peru, I also planned on conceiving my baby. I stopped my birth control several months prior and kept track of my periods. My cycles were not always as expected: sometimes a perfect twenty-eight days, sometimes going six weeks between periods - pretty unpredictable. But I knew this could happen after being on birth control for so many years. So I didn't worry and waited for my body to regulate itself.

Then we were in Peru, hiking and taking in the culture. Towards the end of the trek, I got my period out of nowhere (thank goodness I thought to put tampons in my hiking pack, just in case!). While my cycle had been off, this was different... I wasn't expecting my period for another two weeks. A two week cycle - now? That felt far from normal. Dark clouds formed on the horizon, and I tried to ignore them so I could enjoy the rest of the trip, but something in my gut stayed alert.

After we got back from Peru, I continued to track my cycle and we continued to have unprotected sex in the hopes of getting pregnant. After a couple unusual cycles, those dark clouds started creeping closer, and my gut was encouraging me to speak up. I scheduled my annual appointment, where I expressed my concern to my doctor. She encouraged me to track my basal body temperature so I could get to know my cycles better and use the chart to know when we should be having sex. Perfect - another easy-to-follow formula!

Three months into charting, the data was clear: I had no clue what was happening with my body! I scrutinized the charts to find any clear pattern, any indicator of when I ovulate, but I couldn't figure it out. Again, my intuition piped up, and she did not want me to wait this one out. Despite not wanting to be "that" patient, I again trusted my gut and made an appointment.

At this point I had been off birth control for seven months, so when the doctor saw my charts, she knew it was time to investigate a little further. She scheduled me for an array of tests, and those dark, ominous clouds crept closer again. I can't even remember everything she tested for, but I remember a biopsy of my uterine lining that felt

so invasive and painful, I bawled throughout the whole procedure. I had lost all control not just of the situation but of the way I thought my life would play out. When I looked toward my future, I just saw black - my predictable path was gone. The thoughts in my head spiraled downward as I tried to determine where I had gone wrong and what I could do to fix this.

LETTING GO

Thunder was rumbling, and I was having so much trouble grasping why I was not pregnant yet. As I listened, I heard my internal dialogue turn toward heavy negative talk:

> *Of course you're having issues, you went on the pill to regulate your irregular cycles to begin with.*
> *You're already in your thirties - if you really wanted a baby you should have started sooner.*
> *You're a failure as a woman, you can't even get pregnant.*
> *Maybe you're not meant to be a mom...*

I felt so stupid, like I should have known better somehow and shouldn't have had such idealistic expectations. But in spite of all those harsh statements, in my gut I knew I would be a mom. It was something I knew to my core, and so I couldn't give up even though things were hard and far from perfect.

I suppose it was good that I was so resolute about becoming a mom, because my doctor wanted to test my husband to see if there were any fertility issues on his end. With the results of his test came a thick darkness. The results showed there were definitive fertility issues with both of us, and we would now have to work with a fertility specialist. This information was like a lightning strike to my heart because it felt like confirmation of all the negative self-talk. It also meant that if I wanted to have a biological child, it would be in the least holistic way possible.

This was all so hard for me to swallow. I went into analyze mode again but could not figure out an answer to the biggest question I had: *Why me?* I had done everything I was supposed to, so why wasn't my formula working this time?

TAKE ACTION AND LET GO

With the storm now in full force, I had to navigate it with little to go by, as there is no status quo or path to follow for infertility. On top of that, the possibility of not being able to have biological children was real. I had never known anyone who went through fertility treatments so I felt incredibly alone. It felt like women were getting pregnant all around me. I wanted to be happy for them, but it was so heartbreaking.

I did the only thing I knew how - take action. But this time, I knew I couldn't control the outcome. This wasn't a problem to solve with a logical formula, it was up to fate, God, the Universe - whatever you want to call it - all I knew is that it was not up to me anymore.

Action now looked like a ton of education, weighing options with Ryan and my fertility specialist, and deciding what was best for us. Letting go meant trusting in the team of doctors working so hard to help us have a baby. Action looked like so many calls to our insurance company and the fertility clinic's financial aid team to see how much it would cost us out of pocket. Letting go was trusting that we had gotten enough information to avoid any surprise bills. And this was especially hard because this felt more like a high-stakes bet instead of an investment, and the result was all or nothing - you either became pregnant or you didn't. Action looked like placing orders for medications and needles, and scheduling them for specific days and times. And the ultimate gesture of letting go - trusting that whatever happened, it would be the right thing.

Then it was time to wait out the storm.

Transfer day, the day our embryo would make its journey from the lab into my womb, arrived with a little disappointment - only two embryos were viable. The plan was to transfer one and freeze the others, but I once again had to let go of my plan and surrender to what would be. After a brief discussion with my doctor and husband, we agreed to transfer both embryos.

To weather the storm, I tried not to think about it. I carefully monitored my body for any changes, but I didn't obsess. It was more of a heightened awareness combined with a ton of self-compassion for

all I had gone through. I didn't even take a pregnancy test before my scheduled blood test even though I discovered through infertility message boards that many women do get their results early. I just let it be.

As a way to keep my spirits up, I allowed myself to indulge in signs from the Universe. Before egg retrieval, I had to give myself a carefully timed shot of hormones that would be the final growth boost for the eggs. They call it a "trigger" shot, and no wonder - the needle is ridiculously big! Everything about this injection gave me anxiety - the precise timing, the huge needle, and all that was riding on it. Then one night, I had a banal yet vivid dream in which I simply gave myself the trigger shot without issue. That's it. But it gave me a huge confidence boost.

We weathered the storm, hanging tightly onto the notion of what is meant to be, will be. If I was meant to get pregnant, I would. If I was meant to become pregnant with twins (eek!!), I would. If we were meant to be parents in any form, we would. My whole life, my mom had instilled, "Everything happens for a reason." This was never more true, and I clung tightly to this truth for comfort.

The big day arrived, and my husband and I listened to the message from the doctor together: We were pregnant! For so long, I had tried to get pregnant with a formula, thinking I was completely in control. What I got was a huge lesson in surrendering to whatever is meant to be.

Though my pregnancy was pretty low-key, I did not stop surrendering here. We discovered that our daughter was breech about a month before my due date, she flipped to be head down just days before our scheduled C-section, and she finally made her wide-eyed appearance the good ol' fashioned way four days late. As I write this four years later, Ryan and I are still reveling in the final product of this journey, and we plan to stay a family of three.

While the outcome was conceiving a baby on our first round of IVF and then seeing the pregnancy through to birth, I want to stress that this was just the result of our turbulent journey. Becoming pregnant, and the means by which I had, was the foundation for major growth. If I had not gotten pregnant, I would have found a way to move on. The experience would have served as a pivotal moment in my life in some other way. Yes, I would have been devastated and it would have taken time to heal that wound, but I believe I would have

found it. From this whole journey, I have come away with deep confidence in my resiliency.

This chapter is for those learning to let go, as well as those searching for the silver lining. I would love to hear how my story spoke to you, whether you're on your own journey of infertility or on any path and you're not sure how it's going to end or how you will handle the possible outcome. And just know, everything that is happening right now, is happening for a reason.

ACKNOWLEDGMENT

MUCH LOVE TO MY HUSBAND FOR CONSTANTLY SUPPORTING ME AND NOT CRINGING EVERY TIME I SAY, "HEY, SO I HAVE THIS OPPORTUNITY..." AND THANKS TO NJ TRANSIT COMMUTER TRAINS WHERE MOST OF MY WRITING IS BORN.

(8)

SHOULD

*"I like to think I found myself in
reverse - by losing myself repeatedly,
I unearthed my authenticity
in recognizing who I knew
I no longer wanted to be."*

BY: BRIANA GAGNÉ

BRIANA GAGNÉ

BRIANA GAGNÉ

Briana Gagné is a 9-5 Girlboss, freelance writer, blogger, grand optimist, and extroverted introvert.. Raised in California, she graduated from San Diego State University in 2010 with a BA in Liberal Studies. Post-college, she gypsied around multiple cities on opposite coasts before deciding to plant her roots in the Pacific Northwest. Previously, a deep-rooted people-pleaser, she found herself in the surrender of should.

A known reading enthusiast, it is not uncommon to find her wandering a local bookstore, in downward dog, or sipping tea (not simultaneously, of course!). She has a daily meditation practice during which she usually falls asleep, but is still proud of herself for, and, if asked, will deny how much time she spends giggling at animal videos.

Briana believes everyone has a story and hopes to inspire others by sharing hers. She knows she can't change the world, but believes if we each work to change our own worlds, we have the ability to create a positive ripple effect capable of transcending. Equal parts wanderlust and homebody, this woman finds life is all about balance. The art of surrender has become some of her favorite soulwork.

Briana lives in Oregon with her loves: her husband, the Zs, and their furbaby. She is currently working on her first novel.

www.brianagagne.blogs.com
ig: briana_gagne

WE LIVE IN A WORLD of *shoulds*, where comparison is customary and all too often it is difficult to see the reality hiding behind perceptions and expectations. I categorize *shoulds* as any unsolicited advice based on preconceived ideas of how we are told our lives are supposed to look or how our human experience is expected to unfold. They can be used as a way to manipulate, control, or direct our choices and the choices of those around us. Coming from well-intentioned friends, loving family, favorite books, media, and even our own - conscious or subconscious - inner dialogue; shoulds are assumptions contrived without consultation, removing our free will and the free will of others to create a life of uninfluenced choosing.

We might experience shoulds in the form of shame when we believe we are not enough or feel incapable of meeting others' expectations, or when our lives do not live up to often unattainable standards set by society. Shoulds hide in the picket-fence persona, numbers on a scale, and stereotypes of relationships, families, parenting, and beauty, creating the illusion that one size fits all or that there is a right or wrong way to travel through this adventure we call *life.*

I know this now, but I spent much of my late teens and early twenties struggling with the contrast between the expectations I had for my life, how it should look, and the way my reality was actually transpiring. I am not someone who plays the "what would you change?" game - and although grateful now for my college experience - there were many events during that period that have come to truly define me. Seemingly small occurrences slowly began piling up one after another until who I once was had been buried and I awaited who I would become to emerge from the ashes.

At seventeen, I went away to college. An hour plane ride or eight-hour drive in the same state, yet I may as well have been across the world the way homesickness immediately overwhelmed me in the dorms. I was a happy kid but regardless of how privileged I recognized my upbringing had been, being a teenager comes with its own issues, which often do not discriminate.

Feeling more alone than ever and in an attempt to find my place in a sea of 25,000 students, this anti-sorority girl rushed her freshman year. My preconceived idea of college was based around the assumption that the only way to get the full "college experience" was to join a sorority. I assumed I wouldn't be liked or accepted without those Greek letters plastered on everything I owned and wore. In hindsight,

to me, those sororities were predefined boxes and labels. So rather than having to define myself, I wanted to fit into one of them.

Well, I was completely rejected by almost every single one and my idea of how college should look shattered. Rejection at any age has the ability to create intense pain, but during a time of such uncertainty, it completely derailed my course. Obviously these houses of girls whom I spent only moments talking to couldn't have gotten to know me, so I assumed they made their choices based on appearance. Confidence had never been something that eluded me, yet I began obsessively working out and dieting, believing the outside is what must have needed to change. As silly as I feel admitting this now, my heart still breaks for my eighteen-year-old self. So desperate to be accepted and so insecure she thought she needed to fit in.

This is the influence of shoulds - they attempt to contort us into tiny pre-defined boxes, when in fact we are infinite shapes, abundant sizes, and an assortment of colors incapable of ever *fitting* in.

My stereotypical college experience was not unfolding as planned, but there was still always the highly anticipated prospect of dating. However, the initially mild insecurities I was experiencing soon led me to seek sanctuary in what would turn into an abusive and toxic relationship, eventually stripping me of what little confidence I had left. I was not the "type of girl" who would ever be with someone who put their hands on me. My opinions at a young age were strong on this subject, as I couldn't comprehend how anyone *stayed* in these relationships. *Just leave,* I thought. *Abuse only happens to people who allow it. Right?* Unfortunately, my college boyfriend lived in the apartment next door and knowing him was the first of many harsh lessons I would come to learn in the shattering of stereotypes.

Luckily the "relationship" was short-lived, but not short enough to prevent collateral damage. The next couple of years would be spent highly motivated by should. Walking with, sleeping with, reading, watching, and attentively listening to should. I had lost who I thought I was and the impulse to conform transformed me into a chameleon, morphing into whoever I assumed others wanted me to be or I thought I *should* be. I spent many of these years putting everyone's needs ahead of my own. What I justified at the time as "finding myself" was instead my constant striving to be someone else. Should was my companion, a gentle - *I thought* - nudge in the "right" direction.

I had conformed because I so desperately sought acceptance outside of myself, looking for validation from others and expecting them to tell me the value of my own self-worth. *Maybe I should be more laid-back, wear more makeup, drop less f-bombs, get skinnier, not be so loud or opinionated, be kinder...(this list is infinite).* For years, should was not only influencing my actions, but who I was. If someone didn't like me I was mortified. I would immediately wonder, *what is wrong with me?* At the time, not realizing that so often people's opinions of us actually have very little to do with ourselves and everything to do with them.

Shortly after college, I read an article by author Jessica Valenti that sparked a fire and inspired a change in my tide. In her article, "She Who Dies with the Most 'Likes' Wins." Valenti states, "[...] The implications of likeability are long lasting and serious. Women adjust their behaviors to be likeable and as a result have less power in the world. [...] – it is an issue that comes up for women in their personal lives, especially as they become more opinionated and outspoken."

There was my epiphany. How other people perceive me is none of my business and I will never appease everyone. We will always be too loud or opinionated or shy or smart or silly or serious for someone. We are not supposed to be everyone's favorite flavor! I dare say, if you are everyone's cup of tea and not ruffling any feathers, you may - intentionally or unintentionally – be conforming to your audience. In doing so, we may not always be capable of staying in authenticity. When we don't attach our happiness to something or someone else, the power of our happiness returns to ourselves.

Post-college was the second major time my expectation bubble was popped - repeatedly. I assumed: graduate in four years with my degree, put that degree to use, immediately start receiving a decent paycheck, meet a guy, buy a house, get married, have babies. *That's how life goes, isn't it?*

Well, instead I moved across the country and back in with my parents. *Boomerang generation.* My first "real" job had nothing to do with the four-and-a-half years I spent becoming a certified elementary school educator. Rather I was working in a call center for a hospital - a job my dad had to assist me in getting because apparently not many companies want to hire a new college graduate. For $16/hour, from 8am-5pm, I would tell sick patients the hospital was so overbooked with appointments that I often couldn't even schedule them. Daily I

was cursed at, scolded, scoffed, and yelled at. The sadness of spending my days listening to people's illnesses overwhelmed me. I spent many Sundays crying as I dreaded the work week wondering why there were such glaring contrasts between my life and the lives of those around me. Other times contemplating how my life had become so different from what I envisioned.

After college, most of my friends had moved back to the Bay Area and many found well-paying jobs pertaining to their major, while a few others were off traveling the world. (In hindsight, many of my friends were experiencing similar struggles to me, but of course I was only comparing myself to those who were meeting the standards of what I thought life *should* look like.) I had student loan debt, a job that made me depressed, and - whether true or not - everyone seemed to be figuring life out quicker than I was. During those years, my comparison obsession forced my internal truth and guidance to be overshadowed by the resounding sounds of *should.*

Finally, around the age of twenty-two, I decided the path I had been walking was no longer suited for me. Whether I realized it or not at the time, I stopped living a should lifestyle. Everything did not immediately fall perfectly into place, but I saw the shift. Sometimes you don't need a plan or to meet some expectation, you simply need to breathe, trust, and surrender. I moved back to California, got a place of my own (with roommates), and although it took me a few months, I was hired with a temp agency that placed me into a job I loved and still work at today.

At the age of twenty-four, while out with a group of mutual friends - as the old adage goes - I met a guy. Our very first conversation led me to a few facts key to this next story: he was seven years my senior, divorced, and had two children.

After talking for most of the night, we exchanged numbers. Being the hopeless romantic I am, I declared almost immediately to my closest friends how smitten I was. Having wonderful friends and family, they matched my enthusiasm. Yet as he and I became more serious and the details of his story were divulged, I watched the shoulds come marching back in from a variety of internal and external sourc-

es. *You should be with someone closer to your age. You should date someone who hasn't already gone through a divorce. You should want to raise your own kids, not someone else's.*

In the defense of these shoulds, they came from a place of love with the best of intentions held at heart. I believe most shoulds often do. Some of them even came from my own internal dialogue motivated by comparison. *Do I really want to be the only one in my group of friends with kids already? (Obviously, still managing my comparison complex.)*

Regardless of how many shoulds I had heard in the past and how long I had been attempting to live a life for myself, this was when I discovered its power over me. I also recognized the importance of noticing life's shoulds and taking back that power. Rather than absorbing the advice without hesitation or analysis, I continued to trust myself. Typically, I would have felt obligated to still defend my choice, but with my surrender of should, an innate internal confidence had emerged that can only be described as intuition. I listened to my heart and forged my own path, even if it was the one I perceived to be less traveled and despite its contrast with what others believed my life should look like. We must be the most important influencers of our own decisions.

My experience had become one of surrender of the false conjured ideas of how I assumed the world - and my life - was supposed to look. Instead, I was embracing it for exactly what it was. Concurrently, I was practicing letting go of what others perceived to be best for me and began shifting my focus to what I felt and believed to be best for myself.

After a year of dating, intuitively I knew what I wanted - to be with this man - yet I found it difficult to choose a relationship that was not only vastly different from those around me but also one I had never even contemplated when envisioning what I expected my life and future would look like. One in which I was dating someone who had already been married and was helping raise someone else's children.

I grew up in a single family home with my mom, dad, and older brother. My parents have been married for thirty-five years and my mom was able to stay at home with my brother and me while my father worked. And although I have always been aware of the extensive existence of various types of families, I typically only experienced one. As my best friends were casually dating, going out, or getting

engaged, I was moving in with my boyfriend and essentially taking on the role of step-mom to a six- and seven-year-old. I didn't grow up reading books about blended families or watching movies where she meets Prince Charming... and his ex-wife. *There were step-mothers, but they were basically all evil, right?* My preconceived idea and societal expectations of what a family *should* look like was blurring my vision.

Over time, I learned to recognize should's potential to divert us from being our happiest and, at worst, its ability to derail self-confidence, relationships, vocations, and dreams. I share these concepts not because I have mastered them, but because these are my struggles, too, all of which are a conscious daily practice. When I practice surrendering shoulds and comparison, I feel better about myself and others. A weight is lifted off as I go through my day-to-day moments with a happier, more positive outlook.

Had I not put an end to a life of listening to the shoulds and one of all-consuming comparison, I wouldn't now be married to the love of my life and have the privilege of co-parenting two really incredible little humans. Although the beginning pages to our story were unlike any I had read before - leading us down roads filled with potholes and detours - all of it brought us here. What a beautiful gift we can give ourselves, to embrace the journey. To dare to let go of what we thought would be simply to see what could be. To be confident in our intuition and fearless in our pursuit of happiness. We are not here to be someone else. We are not here to appease others. Have the courage to follow your heart, listen to your intuition, forge a new path, make U-turns, embrace mistakes, love unapologetically, and genuinely open yourself to receive all that the human experience has to offer.

Should need not be stricken from our vocabulary or become this evil, horrible monster. It only needs recognition... and to be gently released back to the wild when necessary. Accept that there is no comparison. Constant comparison is the surest way to rip yourself from reality and remove your ability to practice presence. Allow yourself the freedom of letting go of judgements and control. The idea that we can control others' actions or thoughts - especially in regards to ourselves - is simply an illusion. Welcome the relief that we only can control ourselves so we may honor our journey and the journey of others. Accept where you are. Accept where other people are. You are already exactly who you are meant to be.

We are so many indefinable things. Tiny slivers of every experience we have had, persons we have met, books we have read, and places we have traveled. Billions of puzzle pieces creating the picture of who we **are**, not who we **should be**. The art of surrendering these concepts is a practice in self-acceptance. This is soul work and soul work is about finding the balance between being better than we were yesterday, and purely **being.**

"CAN YOU REMEMBER WHO YOU WERE BEFORE THE
WORLD TOLD YOU WHO YOU SHOULD BE?"
- CHARLES BUKOWSKI

ACKNOWLEDGMENT

TO MY PARENTS AND BIG BROTHER FOR THEIR UNWAVERING
LOVE AND SUPPORT DURING MY YEARS OF DISCOVERY. TO MY
BEST FRIENDS WHOM I'VE LEARNED AND GROWN WITH. AND
TO MY HUSBAND, YOU ARE THE LIGHT OF MY LIFE. THANK YOU
FOR LOVING ME FOR EXACTLY WHO I AM.

9

MY TIMELY AWAKENING

"To truly awaken you must first step into your shadows, only then can you move into your divine light."

BY: LEISA NADLER

LEISA NADLER

LEISA NADLER

Leisa was born in the land of the long white cloud, beautiful New Zealand. After connecting to her soul purpose, she became an Expansion Coach, incorporating aspects of the mind, body, and soul. Setting people on a path of self-love, rewiring the mind, and deep life-changing growth are her passions. Leisa is also a published author, global entrepreneur, and world changer.

Six years ago, Leisa was totally broken, having suicidal thoughts, daily panic attacks, crippled by self-abuse, and feeling stuck in her past. She had a series of life-changing events that allowed her to see that self-worth and commitment to personal growth would heal her life. Leisa is able to help others with their journey to acceptance and enlightenment. With a deeply spiritual approach to coaching, Leisa is dedicated to lighting up the world one person at a time.

She teaches them how to set themselves free and leads them on a path to self-expansion.

www.leisanadler.com
ig: @LeisaNadler
fb: @Leisa Nadler

I REMEMBER IT LIKE IT was yesterday. I was trapped and I could not get out. Why was I so confused, so lost, so petrified to open my eyes? Disoriented to what my life was and where I was, even more so who I was. How had I gotten here? What had happened to me?

You know when you feel like you have been living someone else's life? Like for the first time you stop, pause, and realize what your reality is? That feeling of being on the side and observing your life as if you were an outsider looking in? For me, it felt as if I had been locked in a bad dream, one that I could not wake up from. The beginning years of my life, I had been subjected to sexual abuse by a few men. I had gotten so used to avoiding my reality, I would do anything to stop the nightmares from my past playing over and over again. Substance abuse was my coping mechanism of choice and I used it daily. I never thought this lifestyle choice would ever catch up to me until one day, it did. I found myself in a place I never thought I would be. The path that I had been walking was filled with this protective numbing, but the truth is, there was so much hatred built up in my life for myself that I stopped caring about what happened to me. This led me to waking up in a hospital bed, with no idea how I had gotten there after what I later found out was an overdose. Even saying that word feels unreal. How is it possible that I had let that happen? Lying in that hospital bed, looking around at all the machines, I knew I had to change my life or else next time, I was afraid I wouldn't wake up.

The road to recovery was paved with all sorts of potholes and did not happen immediately. The potholes of temptation, reality, pain, hurt, anger, loneliness, hatred, and an emptiness that I can only describe as feeling lost and not belonging anywhere. I would be lying if I said there was anything easy about my recovery. It was a fight for my life, one that I didn't even know I deserved at the time, or had the desire for. There were a series of practical solutions that helped me immensely and, as I will get to later, Divine interventions as well.

I started to get really healthy. I focused on nutrition and a totally healthy lifestyle. I stopped drinking, I saw a psychologist, and I opened myself up to the possibility of change. Personal development became my world. There were times when I felt the weight of my past bear down on my shoulders and I wanted to go back. That would have been easier. Surrender didn't come in and wrap me up in a cozy blanket in the beginning. Surrendering was a fight to not go back to everything that felt normal and safe. Surrender was scary and

unknown and often physically painful.

In recovery, the withdrawals would have me on my bathroom floor literally wanting to die. The easy road was to go and get that drink but something inside of me said, "No." Somehow I knew I had more life to live. I didn't need any more wake up calls, I'd had mine and it was powerful enough to help me get through the nightmare of realizing I had to live this life for me.

At the time, I had no idea about self-worth. I remember feeling so angry for letting myself get to this point. I felt weak and this was not what I had believed about myself. I thought I was strong but in this awakening, I learned my real strength came from surrendering what I could not control and opening up to help in the many forms it would come in later on in life.

One of the first memories of help I have are two books that came into my life as I searched for purpose and meaning. Those two books were **You Can Heal Your Life** by Louise Hay, and **The Secret**. Someone had given me The Secret years before but I had never read it. Now I was drawn to it. To hold those books in my hands was as if someone had put a magic wand in them and asked me to make a wish on my life. I felt myself awaken to abundance within me. To read each page was like little pieces of pain drifting away, little pieces of my heart coming back to life. I felt myself begin to glimpse into another life - a life of beautiful possibilities!

My best friend was an integral piece of the puzzle, she was my rock. She stood by my side no matter what, she held my hand when I needed it, she picked me up when I fell, she never turned her back on me no matter what I did or said. She always stood beside me and never once was there judgement on her face or sadness in her eyes - she loved me unconditionally. For the first time in my life, I let someone in. I allowed her to see past the masks I was hiding behind, I allowed her to see me. To surrender to being loved was something I had never really fully allowed. She is my best friend and now my sister. Through her strength and love, I discovered and started to understand that I was more than my past. I, too, was a strong woman, a strong woman who could do anything if I just let go, if I just believed and trusted in me.

For the next part of my journey, I knew I needed to seek professional help. I had horrible dreams most nights and nightmares that terrified me. At the time, I was using prescription drugs to help with the detox from other substance abuse, and I wanted to be rid of

those as well. I made an appointment with a hypnotherapist to help with the dreams and the prescription drugs. Little did I know that this beautiful lady would shift me into a mindset that would transform my life to a whole new level of awareness. After working with her, my world shifted, my mindset transformed, my belief evolved, and the constant struggle I had been in started to subside. She helped me stand up for myself in a significant nightmare I had been having for years, and that day I started to believe I had a chance at a future of happiness. I had stood up to the monster in my dreams and I had taken back my power!

When I went back to studying and started investing in my life, I could really see that I had the ability to change everything in my life and believe that I really did have a purpose. I became a sports nutritionist and a personal trainer. I worked every day on becoming a better person. Expansion and discovery became my way of life. It helped me to open up and realize that my past did not define my future, and my mindset became the most powerful thing within my body. My external reflection started to take shape because I was cleansing everything within and realizing that loving my imperfections was the greatest act of kindness I could give myself.

The rose-colored glasses I had been seeing my life through were taken off during these years. I was standing in my truth, which made me so pure and beautiful. I enjoyed my solitude, my own company, I didn't need to be surrounded by people to feel like I belonged. I felt myself evolving into someone I wanted to spend time with. I wanted to understand my thoughts and feelings. Understanding me was a big part of this awakening. I saw that I was tapped into Divine source. My thirst for knowledge became like an addiction - I almost felt like I had replaced one with another. I wanted to understand why I had gone down the path I had, why I had been such an ugly friend to myself, why I had given my power to everyone else and never honored who I truly was.

I repeated mantras and affirmations constantly, things like, "Every day, in every way, I am getting better and better. Every day, in every way, I am getting stronger and stronger." I became my words, I became me! I rewired my mind so that my belief and fear was not the

controller of my life - I was!

I connected to my purpose and started my business. I poured everything I had into this. I had a vision, I had desires, I had a WHY! Once I stripped myself bare, I was able to see everything and my wings started to form. I could feel myself taking flight. I could see myself flying. I believed it could actually happen!

Looking back, I cannot pinpoint the one thing that made me finally fly like the beautiful butterfly that I am. I had so many Divine interventions! One thing I know for certain is that when I learned to surrender, I allowed for light and healing to come into my life. When I learned to accept the beauty I am and stop fighting everything in order to fit in, I realized I was a goddess - uniquely me. I didn't need to form to anyone else's standards, I needed to find my own, to find true pure unconditional self-love. I realized through this that I was safe, I had released the shame, blame, and guilt I had carried with me all my life. Forgiving myself was so important because it allowed my soul and heart to be alive. I have come to terms with what acceptance is. I live in my truth and stand in my power. I own all my flaws with Divine self-love and total acceptance.

There are a few things I want to share based on what I wish I could have told myself years ago to help me when I was living in my shadows. When I had the realization I was living in the darkness of my past, something inside me knew it could be different. Your past never defines who you are: only you can decide that every day. Understand the depths of your mind, body, and soul, and what it can do for you. Enlightenment is your Divine right.

Embrace the lessons, release what does not serve or empower you, and rise with what you have Divinely from within. Be patient with yourself and understand that there is no such thing as failure. Love so hard and never put protection up around your heart. Always believe in yourself with the most unshakeable belief - so much so that you have unshakable faith in yourself no matter what.

We all have had our own journey to walk. I am walking mine and I understand now that life is a journey not a race. Your past does not define your future, instead theses are lessons you needed to learn so that you can become everything you need to be. Everything as it is is part of a bigger plan. One you don't need to know yet - you just need to trust and surrender to the Divine.

Everything I have done in the last six years has led me to a path of non-resistance, a path of forgiveness, a path of enlightenment, and a path of true LOVE!

ACKNOWLEDGMENT

I WOULD LIKE TO ACKNOWLEDGE WITH THE UTMOST GRATITUDE THE SUPPORT FROM MY FAMILY AND CLOSEST FRIENDS. TO THOSE I MENTION IN THIS BOOK, MY LOVE FOR YOU IS ENDLESS. TO MY HUSBAND WHO IS MY ROCK, THANK YOU FOR EVERYTHING YOU.

FROM LACKLUSTER TO ALIVE: HOW LOVING MYSELF CHANGED EVERYTHING

"The greatest love story is the one you write with yourself."

BY: SARA GUSTAFSON

SARA GUSTAFSON

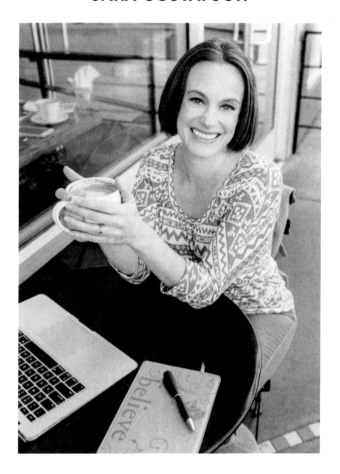

SARA GUSTAFSON

Sara Gustafson is a writer and editor, grammar nerd, dog lover, and recovering perfectionist. She believes deeply in peace, compassion, and the Oxford comma. One of her single greatest joys in life comes from helping other people tell their story, and tell it well.

Thanks to her teacher mother, Sara grew up surrounded by books and became fascinated by words and stories from a young age. Her interest in people's stories led her to major in history at Gettysburg College and to pursue a career in communications. She has been honored to write and edit for the International Food Policy Research Institute (IFPRI) for almost a decade, and she also has been blessed with a variety of fabulous freelance clients who keep her on her toes! Born and raised in central Massachusetts, Sara has lived in seven US states and overseas in South Korea. She now lives in Southern California.

fb: LightLoveWords
ig: @light_love_words
Medium: @gustsa01

O N JANUARY 1, 2017, I popped open a brand new journal and scrawled one sentence inside the front cover, "I want to build a life I don't want to sleep through."

My depression had been rearing its ugly head again, and as always, sleep was my escape. From the moment I dragged myself out of bed in the morning, I would long for the hour when I could wrap myself back up in my shield of blankets. Tired or not, I would find myself crawling into bed on my lunch break or after I finished work, craving a nap not so much to rest as to stop thinking, to block out the dark discontent swirling around in my brain.

One day, during one of these heavy, unnecessary naps, I watched as Clark Kent, our cocker spaniel, looked at me and sighed from the foot of the bed. *Good lord,* I thought to myself. *I'm even boring the dog.* At that moment, I decided that I needed to set a new goal for the upcoming year. I needed to create a life I didn't want to sleep through.

I had no idea what that life would look like, or how I would create it. I just knew I wanted to stop simply existing and to start living. I imagined a lot of external changes – new hobbies, new friendships, maybe a new job. At that point, I never dreamed that all the change I needed was inside me, that the path to my dream life could start with one small but monumental internal shift: Self-love.

WHAT WOULD IT BE LIKE TO LOVE YOURSELF?

If you had asked me on New Year's Day 2017 if I loved myself, I would have responded, "Sure." I didn't look in the mirror and berate myself for my flaws; my days weren't filled with negative self-talk. I had gotten over most of my adolescent insecurities, including a minor brush with an eating disorder. Sure, there were things about myself that I didn't think were perfect – a little less social anxiety would be great – but at the end of the day, at thirty-three, I felt pretty comfortable with who I was.

Then I signed up for a three-week, online self-love workshop run by Pam Davis, a fabulous friend and life coach, and I started realizing that maybe my self-love game wasn't as strong as I thought. I wasn't actively being mean to myself, but I also wasn't thinking about and treating myself like someone I loved. I needed to figure out what self-love meant on a deeper level.

"Self-love" and "self-care" have become buzzwords, but what do they mean? Start by asking yourself this question: *What would it look like to truly love myself?*

Don't just think about it. Close your eyes and let it come to life in your mind. What would you do, that maybe you don't allow yourself to do now? Would you speak more kindly to yourself? Would you start saying "No" to things you don't want to do, without feeling guilty? Would you speak up more at work or in your relationships? Would you spend more money or time pursuing your passions? What would all of that feel like? Lean into it and let yourself feel those feelings, and get excited about them. Because this is where the magic starts.

As I journaled about those questions, these lines tumbled out:

"REALIZING THAT IT'S OKAY TO MESS UP, TO LOOK SILLY/FOOLISH. BELIEVING THAT I'M LOVEABLE, EVEN IF I'M NOT PERFECT."

My jaw dropped. I had never realized it before, but so much of my life had been driven by this belief that I had to be perfect before I could be loved, this fear that I would never be enough just as I was. Apparently, just like still waters, my lack of self-love ran deep.

HOW ARE YOU NOT LOVING YOURSELF RIGHT NOW?

One of the first steps in cracking open our hearts to those first small rays of self-love is simply realizing that we have been in our own way. Then it's time to get down in the trenches and do the hard work of identifying how our lack of self-love has been manifesting in our lives.

Sometimes it will be obvious; maybe you aren't happy with your weight or appearance and so you beat yourself up every time you look in the mirror. Other times, it won't be so clear-cut. That's the thing about a lack of self-love. It can be sneaky, popping up in ways you would never have imagined.

Once I pulled that first thread, I found myself unraveling a big ol' sweater of lifelong, fear-based habits rooted in my lack of self-love. Fear of people getting mad at me or not liking me led me to avoid speaking up and voicing my true opinions and feelings. Fear of looking foolish led me to avoid taking chances or trying something new.

Fear of failing or of not doing something perfectly led me to half-ass things (because if I didn't truly try, I couldn't truly fail). And all of these fears stemmed from this belief that if I wasn't perfect, then I wasn't worthy of love.

As Gabrielle Bernstein says in her book, May Cause Miracles, *"True self-love requires radical self-reflection."* Identifying how a lack of self-love has impacted your life is difficult and emotional. It doesn't happen overnight, and a lot of it will not be fun (although the A-HA moments rock!). But getting crystal clear on the behaviors and patterns that are in our way can help us determine what we need to avoid and draw a solid roadmap to get us where we want to go – that big, juicy, love-filled life we all crave.

Many women, including myself, tend to be people-pleasers. We get so focused on other people's needs and wants that we forget our own matter, or even exist. I had cared so much about trying to make people like me that I never set clear boundaries and never stood up for myself. In fact, around most people, I almost never let myself be myself. I also habitually tried to maintain relationships (romantic and otherwise) with people who clearly weren't good for me and didn't truly care about me. It was like I felt that if I could make these people like me, if I could be good enough for them, then I would be good enough. See what I mean? Sneaky.

Another deeply ingrained behavior that people, including myself, get caught up in is using food and alcohol to numb uncomfortable feelings. I'm not talking full-blown addiction, but just basic unhealthy coping mechanisms to avoid things we don't want to feel. I was trying to numb feelings of fear that I somehow wouldn't be enough. Having a stressful day at work, when my writing wasn't flowing and I was getting close to a deadline? Rather than deal with the stress or face my fear of being a bad writer, I would mindlessly snack. Feeling anxious in a social situation? I would rely on some liquid courage to relax and to seem cool, even if I didn't feel like drinking.

SO HOW CAN YOU LEARN TO LOVE YOURSELF?

The gap between wanting to love yourself and actually loving yourself can seem impossible to bridge at first. I felt terrified, and so that's where I started – my feelings. I gave myself permission to feel what I was feeling in the moment, without judgment and with-

out guilt. So if a blog post wasn't coming together and I was feeling stressed at work, I tried to just sit with that stress, acknowledge it, and name it for what it was.

"I'm frustrated because this piece isn't flowing well, and I'm afraid this means I'm a bad writer."

Naming my emotions seems to take away some of their power, giving me more space to process them and decide how to deal with them. So rather than get swept away by my fear of not being a good enough writer, I can respond to the fear with a clear head.

"I'm feeling fear right now, but I know I'm a good writer. Here are X, Y, and Z examples as proof."

By stepping outside of the whirlpool of our emotions and viewing them more objectively, we can create more space for ourselves to bring in new tools based on self-love, not on fear.

As you get better at these practices, you will likely experience some big A-HA moments, when a pattern or past experience all of a sudden becomes clear. Make sure you take the time to acknowledge these moments, and celebrate them! Celebrating your wins is an incredibly powerful tool that will keep you engaged in and excited about your self-love practice and will drive your progress even faster.

SELF-CARE AS AN ACT OF SELF-LOVE

You won't be having big A-HA moments every single day, though, so how do you make sure you're showing yourself some love on a regular basis?

This is where self-care, another buzzy word, comes in.

Self-care may be super trendy, but it's more than a trend - it should be a way of life. And the cool part is, there is no single right way to do it. The goal is to take care of yourself the way you would take care of your best friend or a child or someone you love. To do that, you need to find what works for you.

I personally love yoga and meditation and green smoothies (I do live in Southern California, after all), but I know people who would rather watch paint dry than do a sun salutation. And that's fine! Forcing yourself to do something just because it's what other people enjoy or because it's trendy and "looks good" is the opposite of self-care. An important part of self-care, and ultimately self-love, is reconnecting with and loving who you truly are, beneath all of the

"shoulds" and comparisons.

Think back to your childhood. What lit you up, what put you so "in the zone" that hours flew by without you even noticing? Playing soccer? Going away to summer camp? Now think about how you can bring back some of those activities in your adult life. Maybe you can't play in a soccer tournament every weekend, but you can move your body every day, even if it's just kicking the ball around the backyard with your kids. Maybe you can't take four weeks off and go away to camp, but you can find a few moments to get outside into nature every day, even if it's just standing with your bare feet in the grass. I loved swinging as a kid – that feeling of gliding through the air, letting everything fall away behind me. I haven't gone out and bought a swing set, but if I walk by a park with an empty swing, I'll take a few minutes to pump my legs and feel the breeze through my hair.

Knowing what works for you also means realizing that what works will change depending on what's going on in your life. This is particularly true if, like me, you live with a mental illness such as depression or anxiety. Self-love and self-care become very different in the face of a depressive episode.

The term "self-care" can bring to mind images of luxurious spa treatments, long bubble baths, and fresh new makeovers. Don't get me wrong – all of those things are great, but self-care isn't all about pampering yourself. It's about taking care of yourself, really listening to yourself, and understanding what you need and can manage – mind, body, and spirit – in that moment. When I'm feeling good, I can think of a million ways to take care of myself (and yes, that includes semi-regular massages). But when I'm depressed, those things seem damn near impossible. So I also have a list of self-care methods for when I'm feeling low. That list includes taking a five-minute walk, taking ten deep breaths, standing in my backyard in a power pose, watching a couple old *Friends* episodes, and making sure I'm hydrated. These actions may be small, but they help reassure me that no matter what, I will always be there to take care of myself.

Because that is genuinely taking care of ourselves – not just being nice to ourselves, but knowing we can count on ourselves, truly trusting that we'll always be there. When we are experiencing depression or anxiety, something as simple as showering can seem like a daunting task. On those days, what we most need is our own compassion; we need to release the judgment of "I shouldn't be feeling this way,"

or "I should be able to do more." On those days, self-care may mean just brushing our teeth. And that is enough. Celebrate it.

SHOW YOURSELF SOME TOUGH LOVE

I talked before about taking care of yourself the way you would a child. As anyone who has spent any amount of time around children knows, taking care of them and doing what's right for them isn't always roses. Sometimes it means saying no to them or making them do something they're not excited about. It's the same with ourselves; just like children, sometimes we need tough love. That's self-love, too – doing the right thing for ourselves even if it doesn't feel good in the moment.

Let's take the food example again. Treating yourself to a delicious piece (or two) of pizza can most definitely be an act of self-love if you're choosing it mindfully, enjoying every cheesy bite, and not beating yourself up about it afterward. It can also be an act of self-love to sit with your craving for a while and decide whether you truly want the pizza or whether the craving is covering up some other feeling. Or to say to yourself, "I know pizza would be awesome right now, and you can definitely have it some other time, but you haven't eaten a whole lot of veggies this week, so I think something else would make your body feel a lot better."

Of course, tough self-love doesn't just apply to food. We need it to help us break all of our unhealthy patterns. When I realized that my fear of not being enough was causing me to hide my thoughts and feelings, I knew I would have to address that habit in order to show myself the love and respect I deserved and to show up authentically in my life. Trust me, breaking that habit has not been easy. The first time I spoke up to my husband about something (something so insignificant that I don't even remember what it was), my anxiety was through the roof – heart pounding, jaw clenched, shoulders up around my ears, entire body shaking, the whole nine yards. It would have been so much easier and so much more comfortable to just stick with the status quo I'd built for myself, to retreat into my old behaviors. But to truly show myself love, I had to be willing to face my fear and stand up for myself.

SO WHAT CAN HAPPEN WHEN YOU FINALLY START TO TRULY LOVE YOURSELF?

As I write this, it's January 2018, which means I'm at my one-year self-love-iversary. In other words – I'm still new at this. I'm still learning. While my life may not look very different from the outside, on the inside, I've seen some pretty monumental shifts.

Speaking up and being authentically myself didn't feel natural at first, and to be honest, it still doesn't feel natural a lot of the time. At first, it was a "fake it till you make it" situation; I was going through the motions because I had faith that good things would come from them, but I still didn't believe that I was good enough, that I deserved to be truly seen and heard. The more I practiced, though, the more I internalized those beliefs until lo and behold, I woke up one day to realize that they were real. I now know, to my core, that I am worthy and enough, just as I am.

Change flows pretty naturally when you are truly committed to changing. It's getting to that "truly committed" part that can be the big challenge. For years, I talked and wrote about the big changes I wanted to make – becoming more confident, being more active, cutting back on alcohol, growing my freelance business, getting my writing published. But for years, that's all it was – talk. Deep down, I didn't believe I was capable of those things, and so they didn't happen. Once I'd built up enough of a self-love base, however, something inside me shifted. I was no longer drowning in doubt, and THAT'S when the big things started happening. I applied for, and got, a new freelance editing position. I started eating healthier and cutting back on drinking almost effortlessly. I started finding more joy and connection in my relationships because I was showing up as myself. I even took a chance on pitching an idea for a book chapter – this one.

Most importantly, I now know that I can count on myself, through thick and thin, one-hundred percent. As I reflect on this first year of my self-love journey – a journey that will last the rest of my life – I know that I have become my own friend. I actually love this woman with whom I am sitting.

As Lao Tzu said,

"THE GREATEST JOURNEY BEGINS WITH A SINGLE STEP."

Making the commitment to surrender our fears and learn to love ourselves can be the first step to the single greatest adventure of our lives, and there's no telling how far it will lead us. This is our beginning.

ACKNOWLEDGMENT

MY HEART'S DEEPEST THANKS TO PAM DAVIS AND THE JRNI FAMILY FOR THEIR UNCONDITIONAL ACCEPTANCE AND ENCOURAGEMENT, AND TO KATHERINE AND KAITHLYN-AWAYS.

ANY LESS OF A WOMAN?

*"We are all so imperfectly perfect
in one way or another."*

BY: JENNIFER BOUDREAU

JENNIFER BOUDREAU

JENNIFER BOUDREAU

Jennifer Boudreau is a lifelong student. From studying business administration with honors, to mortgage brokering, to opening and operating a successful e-commerce business (www.fizznsuds.com), and a blog worth following (www.liferecalculating.com), she just doesn't stop. She loves reading, anything fitness related, eating, and has been fortunate to travel extensively. Her favorite activities are kayaking, fishing, camping, 4x4ing, and dirt biking. She supports, empowers, and educates family members of those suffering with PTSD.

Jennifer is a huge believer in having a bucket list, as YOLO (You Only Live Once) is her motto. She is in a self-directed contest with herself to see what she can achieve in life. Jennifer cannot turn down a museum - from The Royal BC Museum to the Louvre in Paris to The National Motor Museum in Beaulieu UK, she can't get enough.

She is a mom to three beautiful children: two girls and one boy. She loves all animals, but has a soft spot for cats - especially her Maine Coon, Chewbacca (Chewie for short).

Jennifer has been through multiple lessons in life that have taught her to keep going, as the sun has to shine sometime, and says she wouldn't change any of it for the world!

Jennifer was born and raised in Victoria, BC, and though she has lived in many places, home will always be oceanside on the west coast. Jennifer is best known for saying, "Just fucking smile."

www.fizznsuds.com
www.liferecalculating.com
fb: liferecalculating
ig: Groovyjenn1
youtube: PTSD Families Helping Families

FOR DECADES, WOMEN HAVE BEEN coming to terms with what it means to love their bodies on their terms. Over-sexualization has become an acceptable representation of what a woman's body should look like in the mainstream and in many ways, we are still fighting society on this, as well as our own self-judgement. I know I placed my value in thinking that if I had larger breasts, I would somehow be happier. Recently, laws have been passed in both the United States and Canada allowing women to be topless but logically it never made sense for women to have to cover up. Yet from a young age, females are conditioned to think there is something shameful about their breasts, and it has been a root cause of body dysmorphia. Body dysmorphic disorder is a mental disorder in which you can't stop thinking about one or more perceived defects or flaws in your appearance — a flaw that, to others, is either minor or not observable. But you may feel so ashamed and anxious that you may avoid many social situations. I wonder how much of this mental disorder is caused by social stigma? I had to learn to surrender to this, surrender self-judgement. Body dysmorphic disorder can relate to any part of your body and can affect both men and women. For you, it could be your lips, your bum, your cellulite, thin hair, hairy body, stretch marks, whatever it is that bugs you; for me it was my small breasts and I will focus the chapter on that area.

"I MUST, I MUST, I MUST INCREASE MY BUST, THE BIGGER THE BETTER, THE TIGHTER THE SWEATER, THE BOYS DEPEND ON US!"

This was a song sung over and over in my school years. I didn't understand what it meant back then, and in fact I don't think many people did. It was just a catchy song that got stuck in your head. Only once I grew up and realized just how much sexualization of the female body there is, especially the breasts, did the song come back to me - in wonder of its full meaning.

Jugs, tatas, milk machines, dirty pillows, boobs, tits, rack, and even fun bags are terms I have heard used to describe breasts. I'm sure there are more you can add that I have never heard. In fact, I came across a chart that once explained breasts via size on Google:

A cup = Almost Boobs

B cup = Barely Boobs

ANY LESS OF A WOMAN

C cup = Can't Complain
D cup = Dang
DD cup = Double Dang
E cup = Enormous
F cup = Fake
G cup = Get a reduction
and H cup = Help me, I've fallen and can't get up.

I grew up with the ladies in my house having great big breasts, DD and up. I thought for sure my DNA would match theirs and my Almost Boobs would blossom into the wondrous beauties that would catch me a man and be as important in the world as, from my perspective, everyone was making them out to be. Little did I know that my genetics wouldn't grow them. It wouldn't have mattered if I planted them in soil and fertilized them, my beautiful breasts were going to stay on the small side. The smallness of my breasts made me feel inadequate, like I somehow wasn't a full woman.

Indulge me for a moment as I share what I am seeing, and maybe this is something you have noticed, too. Breasts are in your face everywhere. We see them in ads, on TV, at certain restaurants with the waitresses, and in lingerie stores. Breasts are plastered everywhere they can be. It is as though if your breasts were smaller than a DD, you needed to get breast implants. You needed to have these large, gargantuan breasts to wear low-cut anything and to woo your partner and if you didn't have them, you just didn't fit into society. Have you seen shirts made for someone who is a size 14? They have enough room in them for two watermelons, but if you are someone like me who has small breasts but wears a size large shirt to fit your body, it just doesn't work. It looks awful and silently reiterates that you are not good enough. Nothing is made to fit you. I could fit into a size small based on my breast size and then have rolls of fat pop out and have society tell me I'm too fat to wear it - it felt like there was no winning.

My husband was an officer in the military and we went to a lot of functions. Most of them were black-tie dress. I'm not sure what "shape" my body is, but I have a small upper body with almost no chest and a large bottom half. I could never get a dress to fit properly. It was always a chore to get the dress to a seamstress along with a padded bra and silicone inserts to make the dress fit nicely over my missing bosom. It was such a pain in the ass to have small boobs!

When did breasts become so sexual? When did breasts stop being about feeding your children and instead be something for people to gawk at? When did large breasts become the barometer for society's beauty check-off? I remember being told that my breasts would grow after being pregnant and breastfeeding, which they didn't end up doing. While they weren't mosquito bites, they did their job of feeding my children and then shrunk a bit smaller; what a slap in the face! I remember wanting them to be bigger so badly. I would look at ways I could enlarge them online. I found pills I could take to enlarge my breasts, cream I could put on to grow them, padding in bras, even double-padding was an option! So many of the women I knew wanted to permanently reconfigure their breast size by doing a breast enhancement, breast lift, or breast augmentation. These were invasive procedures all for the sake of fitting into a socially dictated expectation of what? What were we running after?

I noticed myself becoming more and more uncomfortable with the size of my breasts. I would wear padded bras non-stop, never to be seen without one. I wouldn't swim without the pads. I would cover myself up so often that it was becoming an obsession and taking over my life. I felt I legitimately needed to have these big breasts. I finally set up an appointment with a doctor for a breast augmentation. Every girl I knew who had one told me it was the best decision she had ever made. From what I understood, they now had backaches and couldn't find clothes to fit because of their big breasts, but they were still glad to have done it. It left me wondering, was it better to love myself or to have a backache (or other side effects from surgery)? I was facing a dilemma. My husband fully supported any choice I made. He told me he loved my breasts and it didn't matter to him if they were small. But the fact was that this surgery wasn't for him, it was for me. I thought I NEEDED larger breasts, as though they could give me some kind of superpower.

At some point, I started thinking about my two girls and began to realize that they probably didn't even know I had smaller breasts because they had never seen me without a padded bra on. What was I going to teach them by getting implants? To not love themselves as they are? That surgery fixes anything? I canceled the appointment because I couldn't get over the guilt of what it could teach my girls. Not that breast implants are wrong, because I don't believe they are, but about buying into society's depiction of how we should feel about ourselves.

"AUTHENTIC POWER IS BUILDING SOMETHING IN-SIDE OF YOU, WHICH YOU CANNOT LOSE AND THAT NO ONE CAN TAKE AWAY FROM YOU."
– GARY ZUKAV

You give yourself your own power or take it away. If I am responsible for giving myself my own power, what was it I wanted? What was a small-breasted girl's dream? What was my dream? This is what I dream of: for society to stop putting so much emphasis on breasts being the staple for whether or not you are "sexy enough," "pretty enough," "f*ckable enough." That's a small-breasted girl's dream, to just be who she is and not be criticized for having Almost Boobs. How did I heal my self-criticism? I stopped focusing on the lack of what I had, and put my energy into what I did have. My brain switched, I surrendered to the power of positivity and gratefulness.

One day, a new friend and I were talking, and somehow the topic of breasts came up. She is about the same size as me, and she told me she'd had a breast reduction. She had been a DD and went to a B. I was astonished because until now, everyone I knew (or rather, everyone I was paying attention to) wanted bigger breasts, not smaller ones. I thought this woman was crazy. Here she was going to the gym, even going without a bra, and loving herself and her small breasts, too. This was so enlightening. It was life-changing. It was exciting! Someone I knew was happy with smaller breasts. Now, I do realize, she had a reduction so it wasn't about loving herself as is but about loving herself with smaller breasts. It made me realize I had to surrender to my "imperfections." I was comparing and judging myself, and hurting my self-esteem. She was happy, she wanted what I was naturally given, and here I was downplaying myself? When we do not show ourselves gratitude, we also lessen our respect towards others. She talked about how her back doesn't hurt, and how she can walk into any store and get bras that fit. Beforehand she would need to go to speciality stores. I couldn't believe she was saying she could do everything that I thought I couldn't. Once I started paying attention to women who were small-busted, I realized they were everywhere, too! It was not just some big-breasted take-over-the-world campaign.

There is a committee called the Itty Bitty Titty Committee... can I get a HELL YA, we belong somewhere! I had now seen people with small breasts who weren't letting it rule their world, so why should

I let it rule mine? I had let it take over so much of what I would let myself do. If I didn't have my pads, I wouldn't go swimming. It's as if I believed I wasn't allowed to be at the beach, I didn't deserve to wear that bikini showcasing my small breasts. Have you been there? Have you had these same thoughts? I realize now how downright stupid it was to put so much focus into something so small (pun intended). My breasts did what they were supposed to do, feed my children. I'm happy to report that I now love my breasts, as they are. If we could just accept each other and ourselves as is, imagine the changes we would see. We don't have to change a thing about ourselves, let's help society change its heart.

"ONCE YOUR MINDSET CHANGES, EVERYTHING ON THE OUTSIDE WILL CHANGE ALONG WITH IT." - STEVE MARABOLI

I now appreciate that I can go into any store and find the cutest bras. I go to the gym without a padded bra, and I even went to the public pool sans pads! YES, no padding. This is huge for me. I love myself as is. If you have feelings that your breasts or any part of your body doesn't meet the status quo, here is what I want you to do: stand in front of the mirror butt naked. Look at what you think your flaws are and pivot them, turn them into positives. Whatever negative thoughts come up, dismiss them, and find three good things about the things you don't like. Write them on post-it notes and stick them where you will see them. When you pass by a mirror, smile and tell yourself nice things. You need to realize you are perfect as is. I was able to start looking at all the benefits of having small breasts: the option to go braless whenever I wanted, more clothes available in my size, shorter breast exams, etc. It might take time to rewire your brain, but keep at it, and you will start to see yourself as the beautiful maiden that you are. I wish I had started practicing this so much earlier in life. I want you to realize how beautiful and perfect you are just being you.

ACKNOWLEDGMENT

MY CHILDREN FOR REMINDING ME OF MY WORTH; YOU ARE THE REASON I HAVE BECOME A STRONG, CONFIDENT, COMPASSIONATE PERSON AND CONTINUE TO LEARN TO LOVE MYSELF.

I WOULD LIKE TO THANK SOCIETY FOR MAKING ME QUESTION MYSELF AND MY BELIEFS, THUS EMPOWERING ME TO PUSH PAST EXPECTATIONS AND BE NON-JUDGMENTAL AND MUCH MORE ACCEPTING OF BOTH DIFFERENCES AND SIMILARITIES.

12

THE RECONCILIATION –
MY JOURNEY HOME

"I am the one I have been waiting for."

BY: MIRANDA SOPHIA

MIRANDA SOPHIA

MIRANDA SOPHIA

A fierce believer in the sacredness of being human and all the experiences that come with it, Miranda Sophia is devoted to getting to know herself in the deepest and most expansive ways in every experience, relationship, and moment that life offers her. Through her courage and willingness to dance with her shadows, walk through the fire, and celebrate in her light, she stands as a beacon, a guide, a facilitator, a space holder, and a sister for others to do the same. By sharing herself fully in her wisdom and vulnerability, Miranda Sophia creates a safe container for women to come home to themselves and embody their innate divinity.

www.MirandaSophia.com
fb: @MirandaSophiaEmbody
ig: @miranda.sophia.awaken

THE CAR PERCHED AT THE edge of the cliff, headlights piercing through the darkness, illuminating the lake that danced below. The dark felt heavy, the snow even heavier. But my body, it shook, and it trembled, and it vibrated with anger, resentment, and hot, seething rage. So much so that I was sure I would explode. So much energy and heat was coursing through me. I had become so good at holding it all in.

I couldn't hold it all in anymore.

It rose up, shot up, filled up inside me until I had to let it out, and I did so in the ways I knew how. They were familiar and comfortable. I projected and threw my rage-filled thoughts towards the person I blamed for MAKING me feel this way.

How can you treat me like this?! You asshole! Fuck you, I HATE you! Why can't you leave me alone?! And then: I should drive off this cliff. That will show you. That will teach you it's not okay to treat people this way. Then you will feel the same pain you've caused me.

I would then *leave myself* to picture my funeral, while my body screamed with rage at being brought to this point, again. I pictured the person I hated, broken and falling apart, just as they had *caused* me to feel.

And then, the self-pity, the victimizing, the defeat would show its face:

THEY ARE RIGHT, I AM FUCKED UP. WHAT IS WRONG WITH ME?

Next came the outburst of salty tears, the ugly, snotty, sobbing tears. The initial discharge created space for the hurt, the pain, and the grief that hid under the resentment, the anger, and the rage to rise to the surface.

The heaviness of the defeat would eventually exhaust me thoroughly, and once I was depleted of tears and self-respect, I would head home, deeply ashamed and ready to sleep. A few days later, I would forgive that other person and continue to silently believe that there was something wrong with *me*.

This story repeated throughout my life. Each time, the pattern embedded deeper into my body, my nervous system, my brain. The stronger the pattern became, the more I tried to fight it, push it down, and hide it, etching the *undesirable* feelings of resentment, anger,

rage, hurt, and grief deeper into my tissues, thickening and hardening them, and further disconnecting me from my true nature.

Despite my grand efforts to avoid, deny, suppress, cover up, hold in, and hold back these undesirable emotions, their power and momentum created cracks within the walls of my defenses. But being with the emotions was too painful, as they were shrouded in shame, disgust, and self-hatred. So instead of feeling them, I would move away from them, abandoning myself and wishing it would all go away.

To avoid what was truly desiring to be acknowledged within me, I numbed out and built up my wall of defense with food and other forms of self-sabotage. I compensated for what I felt were neurotic tendencies by striving for perfection in all I did and was, molding myself to fit in, measuring my success as a good person by how many people liked me, how high my grades were, if I was the captain of the team and the president of the club, if my hair and makeup were perfect, if my body was fit enough. The list goes on.

I just wanted to be seen.
I just wanted to be heard.
I just wanted to be loved.
I just wanted to belong.

But I hid this truth not only from the world, but from myself. Somewhere deep down, I believed there was something wrong with me for even desiring these basic rights.

This defensive pattern of holding everything in and holding my true self back took a whole lot of energy. The energy that was focused towards these holding patterns drained me of the life force that was meant to be fueling my body, mind, and spirit. This manifested into chronic fatigue, brain fog and migraines, constant nerve pain, dizziness, and so much more. My inability to digest the energy of the emotions churning within me manifested into chronic digestive issues. This lack of vitality was paired with the belief that there was something wrong with me, as well as the constant striving to be better and do better. This would push me forward, further away from myself, and all the while draining me even more. My current mind-body integration teacher calls this "driving with the brakes on," and that's exactly what it felt like. Trying *really* hard, while resisting myself.

My healing journey began with my focus on the physical symp-

toms, as they became disruptive to my life of striving and achieving. Without realizing it, I had accepted that my emotional health was just who I was and something I would eventually learn how to cope with.

A lot of time, energy, money, and focus went into trying to find the solution, the product, the practitioner, the line of work, the answer that would **fix** me. Identifying as a walking resource library, my intellect and knowledge became another defense strategy - a gift when I can use it from an embodied place, but it is an addiction when I am using it to avoid being with myself and my emotions. I found many lines of work that inched me forward in my healing and some offered profound insight. But nothing provided me with "the cure" or "the fix" (even though many of them promised this) that I was desperately seeking.

Over a decade after beginning the journey of trying to fix myself, I found myself in mind-body integration (chakra therapy) training. We had been moving through bioenergetic exercises to shift holding patterns in the body and unlock trapped energy and emotions. During partner work, in the middle of an exercise, with thirty other teachers, therapists, and seekers, I had a full blown, kicking, pounding, sobbing breakthrough. A flood of energy and emotion rushed upwards from my pelvis and shook my entire body, erupting out through tears and sobs. My partner and other facilitators surrounded me and guided me lovingly through the release, holding space and supporting me through the process.

Through their love and trust, I surrendered to the experience, following their guidance to increase the charge by stomping my feet and pounding my fists into the ground. Profoundly, while my body was discharging this enormous emotion, I experienced myself as the witness to the spectacle my body was going through. I was actually cheering myself on: "Go, body, go!" As this discharge was nearing its end, I had a moment of desperately wanting to reach out and be held, and for someone to save me from the pain. Before I could act on this, a voice inside, strong and clear, said, "It's okay, sweet child, I've got you." In the loving embrace of this voice, I settled back and allowed my body to complete the process. The sobbing tears turned into tears of gratitude and bliss. The gratitude directed towards those who held me in this process was turned inward. I felt an indescribable amount of gratitude for my strength, courage, resiliency, and for everything I had gone through to get me to that very moment.

Over the following year, that voice would return, becoming a regular within the council of my internal world. So different from the normal internal dialogue I was used to living with, it was clear, fierce, loving, and wise. It often stopped me in my tracks, which I learned was an opportunity to choose a new track.

The first time I heard it after the training was when I was in a changeroom trying on clothes. I bent over to pull up my pants and glanced over at the mirror. Visually I saw my belly, a little bulgy, rolling over my thigh, something that would normally trigger judgemental thoughts or an impulse to suck my belly in. But there was that voice again: "My God, your body is beautiful." And it wasn't just the thought, there was an overwhelming warmth and fullness in my heart that came with it, the feeling of a mother's fierce, unconditional love. I stood up and shook my head, holding my heart to keep it from jumping out of my chest, and welcomed in this new perspective.

A few weeks later, I was getting ready to model for a fashion event. I leaned in close to the mirror to apply my mascara, and there it was again: "My God, your eyes are beautiful. Why disguise them with mascara? People won't see you." I went without mascara to that fashion event (a huge deal for a girl who didn't even take her mascara off to sleep for the better part of her life, for fear of looking like a boy).

Then there were the times when profound wisdom would move through me when I would speak. Sometimes to my son, sometimes to the women in the circles, retreats, workshops, and yoga and meditation classes that I facilitate. This fiercely loving guidance I was offering others felt like it was more for myself.

I began to refer to this wise and loving voice as **Her.** While it was coming from within me, it didn't quite feel like the "me" that I was used to living with. There was a certain feeling I embodied as this voice came through. A mentor guided me to give this voice and embodied feeling a name to further deepen my relationship with Her. When I sat with it, *Queen Mother Wolf* arose. My logical mind tried to fight it, hard. Queen and Mother were both titles, and the perfectionist in me didn't like it. But I was learning that the clear messages I was receiving were much more wise and trustworthy than anything my logical mind had ever offered, and fighting it only made things harder. I was learning to trust and surrender to the fiercely loving voice rather than continue to believe the judgemental and often abusive inner dialogue that I was used to.

As I was assimilating all I had learned and refining how I would present it to the world, I put together the healing modalities that I had trained in, such as body-mind therapies like yoga, bioenergetics, chakra therapy, guided meditation, yoga nidra, and nervous system rewiring, and I used them on myself as I shared them with others. The more I unraveled the non-serving patterns, traumas, defenses, and beliefs that had been stored in my body and subconscious, the less I believed the inner story that there was something wrong with me the deeper I went within myself, and the clearer and more often She came through.

After hosting women's circles for almost two years, I found myself at one as a participant. At one point in this profound experience, I wrote a letter to myself. The second I put pen to paper, it was as though She was speaking to me through ink. The unconditional love that poured through, the validation and appreciation for all of my feelings and experiences, and the unquestioning and wholehearted support that was expressed in this letter blew my heart open. During the meditation that followed, I experienced a mother and daughter coming together in my heart, and as their hands linked, my entire body and being lit up! It was like a majestic celebration, honoring a marriage, or a reunion of a long-lost love. It felt like I was surrounded by infinite beings of light, and there were fireworks, singing, dancing, and laughing!

About a month later, I had come down from the high of the experience and was feeling intensely triggered and charged up after an argument with my partner. I went for a walk, determined to feel better, for I knew better and **shouldn't** be triggered this way. Because my practice and training were thorough, and I had many tools in my toolbox, I was obsessed with finding the one that would bring me peace, that would fix this undesirable state of being. I was clinging and longing to be back in that feeling of celebration, of unconditional light and love, of oneness. The further I got lost in my thoughts, the more I resisted the current state I was in, and the farther I moved away from myself.

Then, there She was. Queen Mother Wolf spoke:

"I AM HERE WITH YOU. IT IS ALL HOLY. IT IS ALL SACRED."

Instantly I was pulled out of my head, through the resistance, into my

body, into the feeling, and into my being... *fully.* The container of my body was suddenly *full...* of me. I was with myself, my anger, my hurt, my gratitude, my joy. Within the container of *me*, it was *all* sacred. *All* of it, *all* of me.

I surrendered into Her embrace and presence, but in the aliveness of the stillness of that moment, there was no **other**: it was **me**.

Queen Mother Wolf was **me**. My Higher Self. My Soul Self. The innate intelligence that is ever present, ever knowing. My internal guidance system. My authentic voice and truth that were hidden below the internalized patterns, programs, and beliefs I had collected throughout my life. She had been calling me, beckoning me, guiding me to reconcile with Her.

I am here with you, I am here for you, I've got your back, it is all holy, it is all sacred.

This became my mantra.

The trust that I, that *Queen Mother Wolf*, would stay with me, have my back, and love me no matter what I was experiencing grew stronger. This gave me the support net, the anchor, and the safe space to unpack an incredible amount of the undesirable emotions I had held in, suppressed, and avoided for so long. At one time, I had internalized that when I felt anger and rage, it meant there was something wrong with me, so I would numb myself from it, or throw it at another, abandoning myself again and again. I could now hold space for it and express it... with myself and **for** myself... knowing I would be there waiting and proud of me on the other side.

This ongoing process of surrendering and trusting deeper into myself, deeper into the wisdom that arises within, more fully into my entire experience of being a human, has been an initiation. This initiation has been an invitation to reconcile with the divinity inside of me, to love myself no matter what.

The poet Rumi offers:

"WHAT YOU SEEK IS SEEKING YOU."

The truth I have discovered is that it was me... it was *me* that was seeking myself the whole time.

This is my time of self-mastery, of maturing into Mother - a reconciliation, a commitment, a marriage with *Her*. It is a vow to be here with myself, to be full of myself, to have my back no matter what, for better or for worse, for richer or for poorer, in sickness and in health.

It is *all* holy, it is *all* sacred - the light, the joy, the bliss, the peace, the failures, the darkness, the rage, and the hurt.

I belong here, in this body, this emotion, this desire, this moment. In this surrender, I have welcomed myself home.

ACKNOWLEDGMENT

TO MY PARENTS, MY SON, AND HIS FATHER - MY GREATEST TEACHERS AND CATALYSTS TO MY HIGHEST GROWTH. TO THOSE WHO HAVE COME BEFORE ME, WALK ALONGSIDE ME, AND WILL COME AFTER ME. TO THOSE THAT HOLD MY HAND, WIPE MY TEARS, AND HOLD ME IN THE LIGHT. THANK YOU. I LOVE YOU.

ACHIEVE SUCCESS THROUGH SURRENDER

"That's where serendipity and magic come from, an intersection of your small inspired steps and the Universe's grand answers."

BY: STEPHANIE DAVIS

STEPHANIE DAVIS

STEPHANIE DAVIS

Stephanie Davis is multi-faceted and loves all things that meld logic and intuition. She grew up alternating between dance recitals and math team meets, and never felt like she was proficient at one thing in particular. She graduated third in her class in high school, and went on through college to earn a Bachelor of Science degree in Aeronautical Engineering. A few months into her first engineering job after graduating, she had a health scare and multiple surgeries that would forever send her life in a new direction.

With a newfound reverence for health and wellbeing, Stephanie dove into all things health, nutrition, and personal development. She started her healthy eating blog in 2012 to share her new discoveries. In 2017, she graduated from the Institute of Integrative Nutrition as a Health Coach and founded Embracing the Mess Health & Wellness. She's here to teach women to embrace their bodies and trust their intuition so they can create the wellness and life perfect for them in this imperfect, messy world.

Stephanie now lives in the Marshall Islands with her husband and loves traveling, cooking, problem solving, coaching, and blogging. She brings a special synergy of practicality and instinct to every project and client.

www.etmhealth.com
fb: @embracingthemess
ig: @healthcoachingbysteph

GET UP IN THE morning and open up my iPad to check my notifications. Shortly after, I start scrolling through the highlight reel that is Facebook. My body tenses and my stomach sinks as I start to compare myself to all of the celebrity health coaches and fitness trainers in my feed. *Why am I so behind in my business? I'll never be able to do a pull up like her. Oh, their wedding was seriously beautiful.* While I do try to be authentic on social media, it occurs to me that people may see my feed full of vacation pictures and beach days and feel the same way. We're so busy keeping track of everyone else's accomplishments, that we barely recognize our own.

Apart from occasional moments of social media hangover, I can say that I truly love this life that I've built, slowly and surely, and I know there is still much more in store for me. I have a successful career, good health, a full passport, and I married the love of my life last year. While I wouldn't be where I am now without some help, I've done a fair share of work as well. Much of it was external, typical Western society hustle. I worked two jobs in college while taking classes full time. People recognize that easily, and it's not that they shouldn't. But there is inner work that our society puts much less emphasis on, and it is equally important, if not more so. When people ask me how I have ended up where I am now, I hesitate in telling them. In some ways the answer is difficult, and in some ways so simple, and I'm afraid that they won't believe it. The answer seems too simple at first and cuts out all of the sweat, the tears, and the miracles. It pays no homage to logistics and offers no clear steps: I surrendered.

That's it - I'm out of the spiritual closet. I'd love to tell my story without going to this place, but I can't.

My foray into the Divine started in high school. I somehow ended up with one of Dr. Wayne Dyer's books and it started everything for me. I read it, but I didn't know how to apply any of its principles. However, reading this one book was the catalyst for me signing up for the Hay House mailing list, which led me to more books about self-help and spirituality. They would send me catalogs (yes, on paper through snail mail!) that I would peruse, discovering new authors and ideas weekly. I started to explore the idea of powers greater than me. A friend introduced me to angel cards, and everytime I shuffled the deck in my hands, eyes closed, posing a question, a feeling of relief would wash over me. I had spent most of my life driven by self-reliance, control, and perfection. I had frequent intense stomach pains

and nausea that no doctor could diagnose. Later in life, I would learn that the main cause of my discomfort was stress and anxiety. Those cards represented the idea that there was Divine assistance I could access and this brought brief moments of comfort and salvation. Even though my mind was being opened to the idea that I could be assisted in this way, I didn't pay much attention to it, as my life was stressful and messy. My parents had recently gone through a painful divorce and I had entered a tumultuous relationship. It was a hard time, but I made it through, focusing on school and multiple extracurriculars and hanging on to glimpses of guidance. I ended up third in my high school class, and even got certified in Reiki energy healing in my spare time. The next four years I spent in college, where I continued on the same path, pursuing both my scholarly and spiritual studies.

After college, where I'd earned my degree in Aeronautical Engineering, I was working as a tour guide at Budweiser. During the day, I'd teach people about brew kettles and canning lines, and at night I'd apply for hundreds of jobs online, hoping to kickstart my career. I wasn't excited about most of the job openings I found, but applied for them anyway. A boring job was better than no job, right? There was a company in my hometown I always thought I'd work for after I got my degree, but when they laid off thousands of people, things started looking bleak. I was stressed, worried about having no money and no health insurance, and I came home every night smelling like beer. To say the least, this was not how I had envisioned my life after graduation.

My Reiki teacher had taught me that sometimes you have to clearly ask for what you want, and put it out there, so the Universe knows what's up. With this information in mind, I got out a piece of notebook paper and I wrote a list of all the things I wanted in my dream job. Looking back, I don't really remember what was on it, but it definitely included good coworkers and some damn insurance. I tucked that list away somewhere and forgot about it, hoping the Law of Attraction would work its magic.

One day I finished giving a tour to a group of beverage fanatics and a nice couple came up to talk to me. They handed me a tip and started asking questions about my life. I told them I'd recently graduated from engineering school and was looking for a job. It turned out their son worked for a company they thought would be a great fit and they asked if he could email me and get my resume. I was excited

about a lead and handed over my contact info. I went home that day thinking I'd just gotten my big break. However, two days later, I heard from the son and he said they had no positions open at the moment. I felt a little defeated but did some research into his company and their parent company, and found some jobs that looked promising.

I applied, and before I knew what happened, I was being flown to another state (my first solo plane ride!) for an interview in between my beer tour shifts. After a few whirlwind interviews, I returned home, not knowing what to expect.

Then it happened. I was standing in the Budweiser Clydesdale barn - a hot, manure-filled place - and my cell phone rang. It was human resources with a job offer that I accepted without hesitation. It checked off almost all of the items on my wish list, including a substantial salary.

There was only one problem. The "dream job" I had just accepted was in a state I had never been to before, away from my family and friends. It seemed devastating at the time. I was scared to move away from home and I almost second guessed the choice I had made by accepting that offer. However, I knew in my gut that this was an opportunity I could not turn down. When we ask for divine intervention, as I did when manifesting my perfect job, we have to be prepared for what we are given to show up imperfectly. Often, it turns out better than what we asked for, but it may not seem that way at first.

I was full of doubt and fear, but I showed up. I showed up for the opportunity presented to me in all of its imperfections and difficulty and kept showing up every day. I've found that the only way to get through moments, or years, of uncertainty is surrendering to not knowing where life is taking me and showing up fully for what is in front of me right now.

The story of my new job may be easily written off as coincidence or luck, and I would do so if this were the only synchronistic thing I had ever experienced. But it is not. There is one thing I can always point to that gets me where I want to be: Surrender. When opportunity knocks and there's something inside me telling me to go to that place, accept that invitation, or attend that webinar, I do it. Even if it's illogical, risky, or terrifying. Especially if it is terrifying, as those things often provide the most growth. Sure, I have intentions, ideas of what I want to do and how I want to feel, but when it comes down to how I'll get there, I leave that up to something, or someone, that knows

much better than I do.

Looking back, my life has been a somewhat convoluted path of trial and error, missteps, and small successes. Strung together, these everyday moments and decisions become me. If I examine the years between major moments, I start to remember where the work happened. I remember every day after my move that I was lonely and sad, when I got up and went to work anyway. I remember the countless hours I spent researching healthy living, natural remedies, and veganism after a major health scare and scarring appendectomy. I started a blog after that hospital stay, took control of my health, and later become a Certified Health Coach. I remember the internet search that led me to the perfect therapist. The book that changed my life. The moment when my best friend assigned my future husband to work in the same place I was working. I look back on my most important life moments: getting that job, meeting the love of my life, having that breakthrough, losing that weight. Every single one of them was serendipitous.

Hindsight blurs together the small moments of each day, but those are the ones that count the most. I sometimes gloss over my everyday decisions and triumphs, forgetting what had to happen in order for me to be where I am now. Every day that I woke up and chose to make that green smoothie for breakfast, I was changing my health and creating a future career. Every page I wrote in my journal after therapy cleared the way for me to create a different life without the same limiting beliefs. Every intention I set, decision I prayed about, and gut feeling I acted upon slowly crafted this life. It is these small moments and decisions that build up, creating momentum around what you want. Don't worry that your dreams won't come true. Take the small steps, surrender, and the Universe bows down to meet you. That's where serendipity and magic come from, an intersection of your small inspired steps and the Universe's grand answers.

Everything eventually happens at the right time, in the right place. Some people may have an issue with the idea of a Higher Power, God, or The Universe, and that's okay. It can also be thought of as messages coming from your highest self, higher consciousness, or even the smartest part of you. The key is slowing down enough for inspiration to come through. We take in so much information these days. Even while we are browsing our Facebook timelines, our brains are reading and registering all of the article titles and pictures at light-

speed. The more quiet time you take - whether that is through exercise, meditation, journaling, or just hanging out and staring at the ceiling after a long day (I totally do this) - the more you will have time to process the day's activities and information overload. You'll start to get small thoughts and ideas that point you in the right direction or show you the next step. It doesn't matter what you call it, it matters that you listen to it.

I am courageous in my surrender and persistent in how I show up for opportunity in my life. The more you ask for guidance, listen, and take inspired actions, no matter how big or small or scary, the more instinctive it becomes. You may not notice the changes happening at first, as the small shifts build up, but before you know it, someone will be asking you how you got to where you are now. They may even tell you that you are lucky, but you will know that it is much more than that.

ACKNOWLEDGMENT

THIS CHAPTER IS DEDICATED TO THE WOMEN IN MY LIFE WHO INSPIRE ME EVERYDAY. THANK YOU, AND TO MY HUSBAND, TIM, MY MIRROR AND COMPASS. I LOVE YOU.

THE ALCHEMY OF MOTHERING

"Motherhood slipped me a hidden gift of magic to transform my beliefs, my world, and myself in service to love."

BY: SARAH RHINELANDER

SARAH RHINELANDER

SARAH RHINELANDER

Sarah was born into a lineage of wise women, artists, earth advocates, farmers, and healers. An avid traveler, she began to venture out into the world at an early age, where she learned profound lessons on the interconnectedness and interdependence of all life and all people.

Shortly after graduating from Cornell University, Sarah was guided to magical Hawaii and began her studies in traditional Lomi Lomi, Rolfing Structural Integration, Ayurveda, Birth Work, and superfood nutrition and cleansing.

Above all else, Sarah is a student of Transformation. She has guided, supported, and coached thousands of people to move through limiting patterns and beliefs and to more fully choose how to walk upon this earth. A successful mamapreneur, she finds great joy in supporting women and mothers to design their lives and heal their relationships with money, receiving, and reclaiming.

A mother of three and long-time resident of Kauai, Sarah is raising her own children in the Waldorf way. Nature, beauty, simplicity, truth, kindness, and wisdom are her muses and she strives to incorporate these elements into her life and that of her children. Her twenty-year practice of yoga and meditation, plant-based diet, and the wisdom of the earth inform and inspire her every day.

www.mymamamagic.com | www.blissmother.com
fb - Sarah Rhinelander
ig - @mymamamagic | @blissmother

HER ART OF SURRENDER

I WAS IN MY BEST friend's house on the Big Island. Sitting on her bed, pregnancy test in my hand. Trembling. Gathering myself to go into the bathroom to check. Even though I was using the test, I already knew. My deep intuition of being a mother was already activated in me. In nine months, I would bear a child, surrender so much of myself and my reality to give life to another.

Motherhood is in many ways the ultimate transformation, the ultimate experience of surrender. As one heartbeat becomes two, then one again, the body, mind, and soul of a mother are transformed by pregnancy, birth, and beyond. Once a mother, always a mother. There is no going back.

I sat in the bathroom of my friend's house looking at the plastic stick with the tiny plus, and in that moment, I was transported through my future. I had never really thought much about childbirth or motherhood before, and I suddenly began to see clearly the images of birthing this baby in the water, at home, my instinct ringing deep and clear within me that the hospital was not my place to give birth.

I remember my midwife Sunni's words months later. I was going to have a tour of the hospital, get familiar with it "just in case" something went wrong or got complicated and I wasn't able to birth at home. The appointment was set for that afternoon, and I will never forget the words she said to me on the phone as I was getting ready to leave. "Why do you want to leave that door open? You know you are going to have the baby at home, going to the hospital will create an impression on you, it will send mixed messages to your subconscious mind." At that moment, her words seemed wise, but as I found out years later, that which we resist most will often come in to teach us powerful lessons of the deepest surrender.

I grew up on an organic farm, raised by a mother who harvested and dried herbs in our back room by the woodstove. By the time I was sixteen, I was a strict vegetarian, teaching my friends about organic and local food. I made homemade toothpaste and used shampoo and soaps that were basically made out of blended up plants.

Needless to say, I was quite a fanatic when it came to what I put on and in my body. By the time I moved to Hawaii a few years later, I was deeply devoted to this organic lifestyle. I began doing cleanses, and studied massage and Ayurveda. I had what many would call an open mind and a free spirit, yet beneath that openness, there were layers of limited world views I was holding onto.

THE ALCHEMY OF MOTHERING

As the birth of my first child approached, I knew what I wanted. Water birth. Cloth diapers, elimination communication, herbal medicine, lotus birth, organic baby clothes, forty days inside, the sacred window, blessing way, and all of my friends bringing us food as we bonded and moved from two to become three.

For the most part, Graciella's birth and babyhood were exactly as I desired. She was born on our deck in a star-shaped kiddie pool, surrounded by my dearest friends as we sang to her while she emerged. I was a strict vegan by that time and raised her that way for the first two years. She never wore a single disposable diaper in her life, and we did have a lotus birth and buried her placenta under a coconut tree. I was facing the transformation of maiden to mother, which meant surrendering some of my identity, although at that time I was not required to surrender any of my ideals.

When I was eight months pregnant with my second child, we left Hawaii, and I gave birth to him in Uruguay. The move was abrupt, in the face of the tsunami that hit Japan and destroyed Fukushima. We were concerned with the radiation and decided to give birth in South America, where there was no danger from the nuclear disaster. Many things shifted for us, and in moments, the world seemed to turn upside down. We were finally able to find a midwife who would support us in a home birth, and proceeded with her guidance.

The process of mothering had been increasing my flexibility for a few years by this time, and I was more willing to surrender some things I was surprised by. We still used only cloth diapers (which all had to be washed by hand and line dried in front of the fire in the Uruguayan winter) and chose not to vaccinate, but we did get the ultrasound that was required for home birth by the midwife.

There were some other spaces in which I had to surrender, especially given the proximity and opinions of my husband's family. I remember lying with the baby on the couch that had become my bed while just a few feet away, his whole family talked and cooked and laughed loudly, and ate, and came over and left... and wanted to hold the baby, and stayed close in our tiny house for what felt like weeks! It was a far cry from the quiet sanctuary we had created in our home for the previous birth, but it also felt amazing to be filled with the love of family. We returned to Hawaii a few months later to carry on with our life, and within two years, I was pregnant again.

It wasn't until this third child that I was truly asked to release and surrender one of my biggest fears and, one could say, limitations. Since before Sunni's words to me during my first pregnancy, I had been resistant to Western medicine, the pharmaceutical and hospital industries, and many of the deeper things they represented to me. I was adamantly resistant to antibiotics and took my children only to the naturopath. In fact, there was a part of me that judged other mothers who didn't live up to the standards I held, who chose to have C-sections, who chose to vaccinate. I had a very clear idea of what was "best" and "right" and of course, with that inner rigidity, something was going to have to give.

I remember it vividly. Just a over a week after my third child was born at home, I was sitting in the large corner room of the hospital. The nurses had just secretly upgraded us into the bigger room because the hurricane was coming. The hospital, ironically, is the safest place to be in Kauai during a hurricane. I had been separated from my other two children for a few days, our first nights apart in their lives. Children aren't allowed into the nursery ward because the tenants are too tender to be exposed to germs. "But if the hurricane comes," the nurse whispered to me, "your children could stay with you here in the room. We could find a secret way for you to all be safe and together."

Oliko was in the bed, sleeping. The machines beeping. My third baby, born at home as of course I had always known he would be. He had been born just eight days before, under the moonlight in the pool on the deck of the crowded cul-de-sac in Kilauea town. The neighbors shushed me, they thought we were out there making love under the stars. Howling at the moon. Primal sounds, *aaaauuuuuuuhhhhhhhh.*

A few minutes later, he emerged, kicking his whole body, head out, limbs writhing inside me. I reached down and caught him in my own arms, held him to my chest, staring at his sweet perfection. His noises, the beautiful first emergence sounds, and the neighbor's voice again from the other side of the fence. "Oh shit, it's a baby!"

He was the most peaceful baby I've held. A tiny master. Sleep eat snuggle sleep eat snuggle sleep eat snuggle. I would wrap him to me and step outside, put a flower behind his ear, introduce him to his world in concentric circles, first the deck where the pool had been, the mountain apple tree that had anchored me as I labored with him, then down to the grass and the lawn, later to the garden.

THE ALCHEMY OF MOTHERING

Back inside, to our quiet space, a cozy sanctuary only sometimes invaded by the complex and exuberant emotions of his siblings. I could lie with him forever, drinking sweet tea and reading books, resting my body, allowing the bleeding to stop and the healing to come. Lying there taking in the smell of him, melting with him. Our plan was tried and true, forty days in the house undisturbed, a list of friends and loved ones ready to bring us meals, simply rest and receive in this first sacred window of life.

A week after his birth, something shifted. I could feel it in him. The peace slowly dissipated. I noticed first his right thumb. The skin was loose. A few hours later, the entire end of his thumb was missing all the skin, not bleeding but raw as if it had been shaved off. I called our naturopath who was still off-island. He said to watch it, it could be anything, and it didn't sound too serious. I could feel my heart beating. Repeating in my mind this new mantra: it's not serious, it's not serious.

The next day, he was different. He could not sleep. Red. Rashy. Screaming. It looked like he had been dropped into hot water. His stomach blotchy and bright. I tried to comfort him, to nurse him, to walk him to sleep, and he would doze and wake again as if being tortured. I felt I was being tortured alongside him.

We searched the internet, and I instantly knew what it was. My mother's intuition screamed to me, but at the time, my mind quieted it. It was too much. The thought of the hospital scared me. Exposing my fresh newborn to the harsh lights and toxic medicines. I was afraid. We called the naturopath again. Called our pediatrician. He told me babies get tons of skin stuff and not to worry.

By the next day, things had worsened. The skin was peeling around his mouth, his lips and his tongue were tomato red. The skin seemed to be melting off of his chin. Diego was holding him tenderly, as only a father can, his face wet with silent tears. We called the pediatrician again and he agreed to do a house visit on his lunch break. Oli fell asleep right before he arrived and the doctor examined him. I looked at the doctor in disbelief as he told us it could be a genetic skin condition or impetigo. He gave us a skin cream. I asked him about what I'd read, could it be more serious, and he said he would have to have a fever for that to be the case. "If he gets a fever, take him to the hospital."

The doctor left and moments later, Oli woke up. We took his temperature; 100 degrees. I took one look at Diego's face and began to run around the house. I grabbed warm socks, blankets for him, a sweatshirt, crystals, diapers. We raced at 80mph to the Wilcox emergency room. This was his first time in a car seat, his first time off the property; the straps didn't fit but we didn't care. Driving fast, his cries urging us on.

Into the emergency room, onto the table, they took off his clothes and his whole body was blistered. Desperately trying to get the IV in, it took eight tries, his skin peeling off in each place they held him, tiny hands and feet, wrists and ankles. Every breath a prayer. Every heartbeat a prayer. Scalded skin. Staph scalded skin. My intuition had been right, and here was my son, just like the pictures I'd cringed at on the internet only the day before.

I had tried to put that part of me who knew better to rest, to ignore that deep knowing. It was this moment I had most feared, the visions of the IV antibiotics that had most scared me. The nurse looked at me. "If the next try doesn't work, we will have to fly you to Oahu for a PICC line to get the medicine in. To save his life." And in that hospital room, something deep in me transformed.

My perspective changed. My fears disappeared. My narrow world view expanded, and I began to pray for him to receive the needle, to allow this medicine that I had resisted for years to heal him. Never have I prayed so hard for anything in my life. Finally, an angel nurse who was working late, was able to get the needle in, on the very last try we had. We sat alone in the cold room in the ER while a machine gave him his first dose of heavy duty antibiotics. For years, I had seen western medicine as toxic, evil, dangerous, and overused, and here I was, crying and thanking God it was saving my son's life.

The ancient alchemists are said to have turned lead into gold. And transmutation is a power we all possess. As a mother, I have transformed challenges into gifts. Tears into smiles. Darkness into light. Resistance into gratitude. Hurt into healing. Poison into sacred medicine. In my heart and my prayers and my vision, I transmuted those antibiotics into pristine crystalline nectar from the Divine, cleansing and elevating my child. The machine an altar, adorned with crystals, a flower, the love of a mother. I laid down my resistance and my ideals and welcomed and embraced this healing.

A few days later, when he had stabilized and I could breathe again, I was on the phone with my friend Victoria telling her the story. The last time I'd seen her was just a few months before, sunning our pregnant bellies on the beach. The first time I'd met her, years before that, was just after she lost her son in an impossibly tragic way. I was seeking the wisdom of a woman who had managed to keep herself from blowing apart in the face of the loss of her child. I needed someone who could teach me that kind of strength as I faced my most intense surrender.

"Sometimes what happens in a baby's relationships early in their life can tell us a lot about their future." Victoria's words to me as I sat in a hospital chair. "Love him, cherish every moment he is with you. Things will never be as we imagine, and we must continue to grow our own capacity for love, and for change." Wisdom from a mother who had lost her boy, to one whose boy had just barely held on.

The hurricane never landed. Oli's skin healed. I spoke to him the whole time we were in the hospital, with my words and with my heart, helping to move the trauma through for both of us. Embracing the gifts wrapped so delicately within the difficulties.

We received many things from our stay in the hospital. I experienced a deep release and surrender of my ideas of what is "good" and "right." Empathy and compassion for parents and all people who are faced with and make difficult choices every day. A softening and gratitude for the medicine coming through when it is most needed. And we unexpectedly received our private sanctuary, quieter and more serene than any room in our home. I had a seven-day baby-moon alone with Oli, our every need attended to, with no other children who needed my attention during that short retreat. The bond that we formed in those days is deeper than I could have imagined. I was more present and in gratitude than I had ever been before, swaddled with prayers and the sweet feeling of relief like no other, that of a mother whose child decided to stay.

ACKNOWLEDGMENT

WITH DEEPEST GRATITUDE TO THE CHILDREN WHO MADE ME A MOTHER, GRACIELLA, ITANU, AND OLIKO. TO THE MAN WHO HAS HELPED ME TO RAISE THEM, DIEGO. AND TO OUR BEAUTIFUL ISLAND HOME, KAUAI.

(15)

UNRAVELING GRACE

*"Surrender will sustain you
and give you exactly
what you need each day."*

BY: MICHELLE TONN

MICHELLE TONN

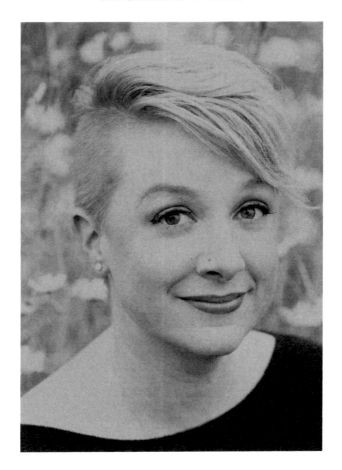

MICHELLE TONN

Michelle Tonn is a creativepreneur who is embracing the beautiful art of storytelling. In late 2017, she made a heart-centered leap to launch her own copywriting business, Emergence Creative, and foray into the depths of writing in which she shares her struggles and triumphs. Her decision to follow her passion for writing aligned with her love of watching clients and students grow. It was a soul project that was a calling to be pursued. When she is not immersed in word-nerd things like the Oxford comma or writing in the third person, she infuses a lot of love, patience, and good humor into her family, friends, yoga practice, animal rescue, and the great outdoors. Join Michelle on her journey as she infuses thoughtful intentions into future collaborations in hopes of igniting a spark within you to create a sense of belonging, serving with purpose and authenticity.

www.emergencecreative.org
fb: @emergencecreativebc
ig: @emergencecreativebc

THIS IS A STORY ABOUT letting yourself be loved in all your imperfect, non-spectacular grace. One day last March, I stared at the ceiling in my office feeling exhausted. I said to myself, *If anyone else wants to live this life I have created for myself, they can. They are more than welcome to try, as I'm done.* I needed a new way to live. I was thirty-six years old, happily married for ten years to a wonderful man, surrounded by amazing friends, family, and community. However, there was a disconnection between peace and my instincts that had me pushing through and I was longing to rest. My health was suffering, I was often sick, and there was never enough sleep. The heart that I used to offer so freely and wear proudly on my sleeve sought protection.

Rather than choosing respite or to heal that internal relationship, I evolved into a person who was unrecognizable. My faith was stagnant and over time it was another opportunity to fail. Life was different than I thought it would be and I couldn't apply the brakes no matter how many times I tried. Accompanied by sickness, little sleep, and a heart that would not be consoled, my mind and body were reacting in ways I had never experienced before. It was difficult relaying how I felt during those moments.

I found myself in a dark season, moving non-stop, wearing my "Superwoman" cape everyday. At least I tried to, acting as if I had it all together and as if I could do it all with a smile on my face because the things I was doing were good for the community, work, friends, and family. Serving those who needed help, and sharing myself with anyone who needed a hand up. Yet in the midst of all these seemingly good things, I lacked a nearness to my heart and respect for myself. I lacked the first sweet love that I had for my faith and strength in who I was. Journaling, self-care, and spending time with God: just to be refreshed was something I considered a luxury I didn't have during that season. But in fact, I was also afraid of deconstructing my truth and bringing it to the light.

I have come to believe there are seasons in our lives that change us, when the old is gone and the new has come. Most days I awoke looking battered from frantic and frayed living. Experiencing stomach issues, fatigue, moments of sadness, and motivational issues for several months, ignoring them, and masking my symptoms as stress-related. Fast forward to midday, when I would be on the phone at my work desk, listening to a client unload his panic because his project

timeline was behind. Looking back, it was easy to see that I was at my worst: weepy, snapping at everyone, with anxiety sky-high. The deep connection to God, myself, and the people I loved most at an all-time deficit.

It's often said that change doesn't occur until the pain level gets high enough. This self-insight into my life was heartbreaking, as I felt broken beyond repair with a burden too heavy to carry. The life I had built was breaking to pieces. There were times when I was so desperate to escape my paralyzing fears that I would end up curled up on a bathroom floor, feeling humiliated. I silently acknowledged that I had neglected underlying feelings of self-doubt and untruths, which manifested within my body as a cry for recovery and to seek my truth. Grasping onto a self-identity that was no longer mine to keep.

DEPRESSION, ANXIETY, AND GRACE

After one of my humiliating breakdowns, I was recounting my moment of panic for our family doctor as I filled out the happy faced questionnaire. The one where you have to identify your emotional baggage on a scale of one to ten while the medical professional studies you for cues of self-harm and delusions. Fortunately, I had experienced none of those but I still felt incredibly broken. How was I going to convey that I wished to move from exhaustion to peace, isolation to connection, multitasking to being present? Instinctively, I allowed my body posture to soften and accept the offer of help as my doctor prescribed a treatment plan involving a temporary antidepressant, exercise, and respite. This was *my* moment of complete surrender, allowing the feeling of gravity and a weight lifting off my shoulders for the first time in months as I acknowledged my diagnosis.

In the early stages, it was difficult to be alone with my own thoughts, as I had learned to trust sources outside myself, listening to the voices in the crowd. Believing it was better to measure my worth through external metrics than through values deeply rooted in my soul and spirit, I attempted to create external changes first, which I imagined were about time management and balance. I quickly discovered it wasn't about to-do lists, scheduling time, or housekeeping but about love, worth, faith, and God; reacquainting myself with Him in a way that grounds and reorders everything. Allowing for an emotional, physical, and spiritual realignment.

In those moments when I felt the impossibility of recovery, God met me. The anxiety attacks were my body expressing a need to stop, recalibrate, and recover. An open invitation to allow grace within my life. To move from exhaustion to peace, from isolation to connection, from multitasking to being present - this was the beginning of restoration. As God has continued His restoration process in my soul, there has been a freedom in telling people my story without the veil of shame covering my face. Over the past year, He has taught me that the invitation of surrendering to grace is greater than our lowest moments.

If you've suffered from severe anxiety or depression, you can likely relate to crippling, out-of-control worry that affects not only your mind but your body's ability to function. Having never experienced this before, I was unwilling to admit what the problem was for months. I wanted to simply move past my fears in time and under my own strength. But as I started reading books and consulting with a counselor, delving into my spiritual practice and realigning with nature, I realized that the darkness had, in a sense, rewired my brain and body to resort to panic in moments that were actually safe in an attempt to protect myself from harm. My anxiety and depression were misplaced fear. Ultimately, the darkness placed me in a cage that hindered me from living the full, abundant life that Jesus came to give (John 10:10).

One morning while hiking with the dogs, listening to the ocean surrounding us, God led me to Lamentations 3:22-24, a passage I had read countless times before. It wasn't until I was completely desperate that these verses actually made sense to me. In this passage, we learn that God will never let anything in this life overwhelm us to the point of ruin. Ultimately, it is His grace that overwhelms us (in a good way) and engulfs us in His love. When it feels like we are drowning, we can know the life jacket of grace is always within reach. Why? Because His mercies are always new, His grace is greater than our lowest of lows, and His love is deeper than our breaking points.

God would not let my panic, fear, or the unknown consume my life. Even though it felt like I was sinking, He wouldn't let me drown. The panic that my soul and body experienced last year was God's gift of grace reminding me that I am limited, but He is unlimited. I am broken, but He is the great physician. When I am drowning in fear, sorrow, or anxiety, His new mercies overwhelm me like a hurricane of peace.

GRACE AND SURRENDER

If you're in the thick of battle right now, you're probably wondering to yourself, *What now? If there's hope, how do I grasp it? Is there really freedom?* The answer is a resounding YES.

There is nothing superficial about this process. I have failed many times, praying, fasting, and reading countless books. Beyond those things, the most life-altering aspects of the work are those that I had not done. I had not allowed myself to stop, rest, breathe, and connect. I had not been accepting an invitation to surrender. I am by no means at the end of this journey, but I've traveled along this beautiful road long enough to understand that this is how I want to spend the rest of my days.

Richard Rohr said,

"THE SKILLS THAT TAKE YOU THROUGH THE FIRST HALF OF YOUR LIFE ARE ENTIRELY UNHELPFUL FOR THE SECOND HALF."

The skills I developed for the first half of my life made me responsible and capable, but tired. Becoming productive and practical, I moved myself away from the warm, whimsical person I used to be. And I missed that person, desiring to be perceived as wildly competent and vulnerable, with a willingness to stand tall in who I was. Not the smoke and mirrors version with all the accomplishments or achievements, but to say, "This is me," with all my limitations and weaknesses. It's as though God in His graciousness and wisdom pressed His thumbs into the wounds of my life, the desire to prove and the desire to escape.

I've learned to stand where I am planted, being present and grounded deeply in the love of Spirit, which is changing everything. My hope is that this journey inspires you to leave behind the heavy weight of comparison, competition, and exhaustion. To surrender to a life with meaning, connection, and unconditional love.

In my own moments of panic and anxiety, here are some of the things that I've learned to start doing to reclaim my thoughts:

BREATHE. In moments of panic our heart rate rises and breathing becomes shallow (thus making panic worse and reducing clear thinking). Make it your first priority to take long, slow, deep breaths. Training ourselves to pause, breathe, and pray in moments of worry and anxiety is key to connecting with Spirit. When you go through

moments of anxiety, breathe first and pray. During meditation or prayer, bring your fears to the surface so you can move through to a sense of peace. When you bring this to God (or your own connection to a Higher Power) in silence, that's when connection begins. I was a woman who had not trusted God with her vulnerabilities for a long time. Ungrounded, I was flailing to connect to something bigger than myself. Eventually I allowed myself to be seen and loved in full capacity. It changes us as we do this, grounding us to a reality of love to hold space for others and ourselves.

ADDRESS AND ACCEPT: Facing our vulnerabilities and wounds allows us to pivot our thinking by accepting the darkness and light within. It can be hard for us to grasp that we possess the agency, authority, and freedom to make our lives smaller or larger. But accepting them and our frailty is a way to peace.

We all have complicated tangles of belief, identity, and narrative. At one time of my life, ability meant walking into rooms where I was invited, and not having to work relentlessly to prove I was worthy of being invited or accepted. I could not imagine a world of unconditional love or grace, where people confidently entered into rooms, as my daily surroundings were within male-dominated industries based on earning quotas and validation.

I wish I could tell you that when my health initially suffered in my mid-twenties I listened to my body and changed course. Regrettably, I didn't honor my body but continued working while suffering the effects of a miscarriage.

I eventually realized that the return on investment was not what I imagined and the expectations were only greater. To return to love, you must return to the silence, honor the outcome, and reframe to move forward.

REPLACE LIES WITH TRUTH: We've got to address how we feel and then move forward with the truth. Anxiety is caused by a belief or fear. Rather than letting those fears guide us, we need to address them, name them, and replace them with the truth. I've found in my own life that this is best done through talking out loud to a trusted friend or counselor. Speaking lies out loud takes their power away. But even more, we have to replace the lies we are believing about ourselves, our situations, and those of others with the truth that brings freedom.

GET MOVING: Don't just sit in your anxiety and panic. Get mov-

ing. Go for a walk. Serve someone and take your mind off of yourself. Turn on music and hum or sing to the tune. When we get moving and go forward in grace and strength, we are proving to our anxiety that we won't stay stuck in it.

SEEK WISE COUNSEL: When battling anxiety and depression, we must remember that the anxiety is a symptom of underlying fear, doubt, or those ever-so-common "what if" questions that plague the human heart. Seeking out a wise confidant to uncover the anxiety or depression is crucial. Many of us are embarrassed to see a counselor, mainly because we place unprecedented pressure on ourselves and each other to "get it together" on our own strength. However, we need to identify this differently. Stepping within ourselves, we discover that often we need someone on the outside of our struggles to help us see the truth and move forward.

Your breaking is not for your destruction, but for your remaking. God won't leave you where you are; He is taking you somewhere. You aren't broken forever or alone as there is healing to be found within. When anxiety and depression come, know that He is walking through it with you and will always bring you through to the light. It's a daily, moment-by-moment choice to choose surrender and trust, and yet it is always worth it. When the world is unstable, chaotic, and "out of our control," we can trust within the Spirit's steady, consistent, and never-ending grace. It's our stability during times of transition.

The greatest encouragement I want to offer to those walking through a season of transition is this: Don't neglect yourself because your home is torn apart or your to-do list is long. Spirit is your lifeline, it is your stability, and it is your comfort. No matter where you live, no matter how messy your home becomes, and no matter how you feel each morning—His word will not disappoint or fail you. Your life may look different than you expected, and your worldly comforts may be gone for a season, but surrender will sustain you and give you exactly what you need each day.

ACKNOWLEDGMENT

THANK YOU TO MY FAMILY AND FRIENDS WHO HAVE INSPIRED ME TO BE FEARLESS. SHARING GRATITUDE FOR MY MENTORS IN ALL FORMS.

RUTHLESS SURRENDER: THE MOST LOVING THING YOU CAN DO FOR YOURSELF

"Give yourself permission to create the life of your dreams."

BY: NARELLE CLYDE

NARELLE CLYDDE

NARELLE CLYDE

Narelle Clyde is an Ascension Coach, Healer & Channel for Light Language, with a mission to guide you on your journey to clarity and purpose. Narelle works with men and women seeking the next level of freedom, abundance, and ultimately, a life and business by their own design.

Her genuine love for all humanity drives Narelle to want to see everyone succeed, knowing that we all have unique talents to bring to this world. She has a natural gift for unlocking greatness and activating your full potential.

Narelle brings her extensive experience in the discovery of connection to self, source, and manifestation to ignite your inner flame and inspire you to step into the next level version of yourself, now!

www.narelleclyde.com
fb: NarelleClyde
ig: @NarelleClyde
in: in/narelle-clyde

THAT UNMISTAKABLE TIGHTENING OF THE chest that crawled all the way up, into and around my throat. I was being strangled from the inside out. Why couldn't I breathe? Think? Speak? It traveled up further, into and around my head, slowly molding every inch of my mind with a heavy fog. I'd been here before, more times than I cared to remember, actually. Often this feeling wouldn't lift for days, sometimes weeks on end. Bang... there it goes, traveling right back down, into the depths of my stomach... ugh, that heaviness, that nausea, twisting and turning. I had allowed myself to sink, once again, into the deep, dark vortex of the unknown yet undoubtedly familiar space of despair. I had now been prescribed medication for this at twenty years old because this desperate feeling of anxiety had crippled me to the point of not being able to work, and some days I simply couldn't get out of bed. This was devastating to me. I was a personal trainer and group fitness instructor and I felt as though I was failing myself and my clients - how could I be promoting health and wellness when I was feeling the exact opposite of that? It was as though I had fallen off track, I wasn't on the right path and now found myself on a mission to discover my true identity. I knew that on some level I was a powerful being, with the ability to create my own reality, and take control of my life.

I decided in that very moment that I would no longer tolerate what always had been. The message I received was crystal clear: ***"It's time for you to take back your power, it's yours."*** This voice came through like a steam train between my ears. ***Who was that? What was that?*** My Higher Self, my Guidance, my Soul was talking directly to me, and, finally, I was hearing it loud and clear. It had been nudging me for years and I had not been listening or trusting my inner Divine Guidance. I felt the courage to find faith in taking the next step forward, and this led me to a one-way ticket from my home in England to The Land Down Under - Australia.

I had no idea what would happen when I got there, I only felt my soul's calling to travel and explore, which I knew would lead me to discovering more parts of myself and who I really was. This beautiful journey took me far and wide, where I experienced the highs and lows that brought me back to myself. I found my next calling in the travel industry, creating dream adventure itineraries for hundreds of people from around the world. In addition to being invited to travel all over Australia and New Zealand as part of my career, I made some

incredible friendships and settled into a life that, at the time, was the ultimate in freedom and adventure.

Then one day, ten years later - snap! That old familiar feeling came hurtling back at me. **How did I end up here again?** I asked myself, frustrated and confused. This time, I dug deep. Really deep. What I came to realize was that, yes, I had followed my soul's calling and it felt great. But I had forgotten to keep listening along the way. I had distracted myself with being busy. Busy with life and travel and work - it meant that I hadn't been tuning into what was really going on internally for me. My soul was crying for help once again. Only once I was struck down with a frozen shoulder did I take a moment to stop. Just pause, take a breath, and listen to what my body was communicating to me. Honestly, I had to laugh! Through the immense pain I was feeling all day, every day, for weeks on end, I had this enormous realization: if we do not pause, stop, and tune into ourselves... our body will create a way to make sure we do it. I was in awe of how connected we are in mind, body, and soul. There is nothing our bodies will hide from us, it's up to us to observe and listen.

This time I made a promise to myself that this was it, it was time to listen and fully surrender to stepping into my greatness. My body was telling me that I was carrying the weight of other people and I realized that for too long I had been playing small and sitting on the sidelines, giving my power away over and over and over again. I could see clearly for the first time in years. It was as though my life was flashing before my eyes and I saw moment after moment where I had put everyone else's needs, thoughts, and feelings before my own. These small experiences had built up over time and left me now in a place of not knowing who I was or what I was here for. I questioned everything. The only thing I knew for sure was that it was time to find out and that meant complete, total, and utter surrender to the unknown.

THE MESSAGE I RECEIVED WAS THAT I HAD TO BE RUTHLESS AND COMPLETELY LET GO OF EVERYTHING AND EVERYONE THAT I WAS NO LONGER ALIGNED WITH.

I saw clear visions of various people in my life that I was being guided to let go of. The realization of what was about to unfold felt like my world was being flipped upside down. You may have heard

the idea that our environment is absolutely everything. This became my truth. I was being asked to remove everything that was not in direct service of my life and it was time to live from my highest good. I felt the power of this and knew it would allow me to expand beyond all expectation. This scared me senseless to say the least! On the one side, I had to burn everything that felt safe, comfortable, and familiar. On the other side, I was being called to step into the highest level version of myself. I had the fear of loss and of success all in one. In order to follow our soul's journey, everything that no longer serves our Higher Self simply has to go. For me, this was not an easy process. It was painful and heart-wrenching and devastating at times - when I let go, I surrendered to all of it.

I had been in a loving relationship with a wonderful man for ten years up to this point and could see now what I had been unconsciously resisting. It hit me like a bullet to the chest, powerful and heavy, because I knew that I had to end it. We were on completely different paths, and although it was glaringly obvious to me now, we had been burying our heads in the sand for a long while. Our journey in this life together had come to a close and it was now time to move on separately. Ending a relationship that looks, on the surface, pretty perfect is no easy task. Especially when the other person cannot see what you see, or feel what you feel. The hurt and heartache is almost unbearable. Feeling as though your own heart is being ripped out of your chest, as well as the other person's. Even though I knew for sure this was the best decision for both of us, there was a grieving and healing process to move through. Choosing to honor and love myself first, beyond anything or anyone else, was a journey of discovery. This was my choice, to recognize that staying meant going against my own soul, and that was not an option I wanted to take.

Not only was my personal relationship ending, but my professional one was, too. This was a time in my life when I'd had the opportunity to spend some of my career with a big influencer, thought leader, and personality. This was a magical part of my journey during which I grew exponentially and discovered incredible parts of myself that I didn't even know existed. There are many wonderful experiences from this time and I look back on it with nothing but love and respect. However, within this role, I was not able to step into my true greatness and I found myself hiding behind an identity that wasn't me. It took some work and healing to realize and own this within myself. To face

my fears of the unknown and stand tall in my courage. In what almost felt like the flick of a switch, I left my "dream job" and a sisterhood friendship in the desire to find myself, my voice, and to walk fully on my own path. Even writing this right now is a process of surrender. There is a lot of love in the relationships I reference here and it hurts knowing they will never again be what they were. This was painful and scary at the time, stepping away from relationships that didn't align. However, reclaiming my power, being ruthless in the surrender, and ultimately letting go of people's expectations became the most important and honoring thing I could do for myself.

Regardless of what was going on in my outside world, I found that every day, I was becoming more and more divinely connected to self and source. From what I understood about the Law of Attraction, I knew this meant that my outer world would soon reflect this. When we step towards the Universe, it steps towards us. I had to show that I was serious about going after what I wanted. This was the next level of manifesting my dream life: stepping forward into the unknown. Surrendering to all possibilities felt limitless and like I could finally live without any judgement from myself.

THIS PART OF MY SOUL JOURNEY BEGAN WITH GRATITUDE.

When we are emitting the frequency of gratitude on a consistent basis, we are ultimately stepping up to the frequency of the Divine and from there we have the ability to manifest anything we want into our reality. I felt deeply into how thankful I was for the experiences that had led me to this point in time. Let's be real, this took some conscious effort, considering I'd just burned my old identity, released loving relationships, and became brutally aware of the wounds this had exposed in me. It was now time to step up and manifest my dream life.

The process of manifestation starts with asking for what you want - so what was it that I deeply desired? To be of highest service to this world, to speak my truth, own my power, and show people what is possible in life. To call in soulmate clients who do the work and are committed to uncovering their own inner Divine Power. To call in a passionate, magical, soul-connected relationship. To continue to travel the world, living and working from some of the most beauti-

ful locations on this planet. To live a life entirely by my own design with absolute freedom and abundance. To feel expansive, whole, and complete exactly as I am. The list and the detail was extensive - I was crystal clear on my desires for the first time in all my life! It felt amazing to finally declare what I want to the Universe and without one shadow of a doubt, I knew it was going to show up. I did not once question the how - I simply surrendered and trusted that it would be, while having infinite gratitude for what was already in my life. One of my favorite mantras is, "The better it gets, the better it gets." I feel this is a pure representation of how wonderful it is to drop into positive momentum and carry it through every second of the day.

The next stage of manifestation is to ask, "What else is possible now?" Feeling into the expansion of this question allowed me to realize that there is always more - another favorite mantra of mine! It's so important to look at what is beyond your dream and your vision to allow for all possibilities to flow into your life. There is always a next level to enjoy and explore.

Trusting that inner nudge, that little voice inside of you, and surrendering to it completely can feel like jumping off the edge of a cliff, uncertain of whether you'll fall or fly. What is possibly one of the most intimidating moments of our lives can rapidly shift into absolute, infinite, and Divine flow. The art of surrender is trusting in the unknown. Having absolute expectation that everything is always working out for our highest good, without any attachment. To fully surrender is by far the the most honoring thing anyone can do for themselves. From this space, life and love flows through you, and miracles appear every single day.

ACKNOWLEDGMENT

I WOULD LIKE TO EXPRESS GRATITUDE FOR EVERYONE WHO WAS A PART OF THIS JOURNEY, AND ACKNOWLEDGE ALL OF THE WOMEN WHO MAY FIND INSPIRATION THROUGH MY EXPERIENCE.

17

THE BACKPACKER'S PATH TO PURPOSE

"We are unique and intricate puzzles, each piece cut from our own experiences."

BY: MICHELLE CHAN

MICHELLE CHAN

MICHELLE CHAN

Michelle Chan is a charismatic, kind-souled healer who lives to make the world a better place. Currently residing in Vancouver, BC, Canada, she absolutely adores people, which led her to become a Registered Massage Therapist. Michelle completed the 3000 hour RMT training program in December 2015 and has quickly become successful in building her practice. She enjoys facilitating the healing process and helping people feel good. She hopes to be working in a massage school as a teacher's aid and clinic supervisor by the end of 2018. Her long-term goal is to gain enough experience to immigrate to New Zealand and progress her massage therapy business. She has backpacked to over a dozen countries across five continents and hopes to explore Europe before the end of 2019. Michelle has based many of her life decisions around her favorite hobby, snowboarding, and hopes to one day snowboard on all seven continents. She also trains in kickboxing, practices yoga, and lifts weights to keep fit. In her spare time she volunteers with Street Saviours Outreach Society, a community outreach group for some of the most vulnerable and at-risk members of the Vancouver Downtown Eastside, as well as Good Night Out Vancouver, an international organization that helps bring awareness and prevention of harassment and sexual assault to the club/festival scene.

michellechanrmt@gmail.com
fb: michellechanrmt
ig: mushmellow11

AS A YOUNG GIRL, I was vivacious, full of energy, and excited about life. Somewhere along the path to adulthood, my light became dim. Most of my elementary years were average, although I did tend to gravitate towards the outcasts and unpopular kids. In my high school years, this became more common. I met a group of kids when I was about fourteen who were drinking heavily and experimenting with drugs. By age fifteen, I was attending raves and living a life of party and pleasure. I had found a community I fit into, and an unhealthy lifestyle to go with it. In my later teenage years, my happy-go-lucky self started to take a turn for the worse. I had two major relationships that were affecting me in a negative way: my boyfriend, Thomas, and one of my best friends, Leanne. My boyfriend suppressed me and my best friend stressed me.

Leanne came in to my life at a rave when I was seventeen and we quickly became best friends, moving in with each other a couple of months after meeting. She is a wonderful person, with a great soul and hilarious personality. On the flip side, she has mental health issues and sometimes life became too much for her to handle. I became the saving grace when she started to lose control, calling me at all hours of the night to fix situations. I didn't understand the importance of boundaries at that stage in my life, so I exerted a lot of energy to save the day. Leanne was also suffering from alcoholism which, mixed with mental health issues, can be very draining and dramatic. Paired with recently having a baby girl, her emotional state was extra sensitive, and being the safety net all the time was taking a toll on me. I have a history of putting other people's needs in front of my own because I want to help them. This is still something I do, and I am continuing to work at this on my path to self-discovery. This was my first lesson in surrendering. To let go of unhealthy relationships in order to grow. My life had gone down a route I was not happy with and I needed to get it back on track. I started with my relationship with my boyfriend, who became my ex, and took a large step back from my best friend.

After many years in the electronic music community, actively involved in promoting shows and club nights, I met a man who I ended up falling in love with. This man, Thomas, wasn't in the rave scene and was oblivious to the lifestyle I had been living through my teenage years. Since he didn't approve of my lifestyle, I ended up taking on his whole life: his friends, his hobbies, his family. I spent every day with him, and essentially moved into his place. Over the next couple

of years of dating Thomas, I gradually pushed all my friends away, and the ones who stuck around were generally dysfunctional. They were the type of friends I would party with, keeping it all a secret from my boyfriend to prevent a fight. I lost interest in all the hobbies I used to love, I lost the friendships I spent years building, and eventually I lost who I was. I was stuck in someone else's life, and for the most part, I was miserable. As in most relationships, there were plenty of successes and achievements, but after a few years, they became clouded by my dark emotions. Being the immature young adult I was, I didn't know how to communicate well and held most of my feelings in. I felt trapped and caged - I needed to break free and I didn't know how. There was undying love for the man, but not the life.

I evolved into an angry and jaded individual who fell into depression and found little joy in my life. Drugs and alcohol became a crutch for my emotions. At the time, I was also working in an office for a company that went against my values and I absolutely hated my job. I dreaded going into that office every single day. I realized I had become completely dependent on Thomas for my happiness, since I had pushed all my other friends away. I needed attention from him to feel worthy and wanted. When he began dating someone else after we broke up, I became jealous and manipulative to keep him in my life. I was needy, emotional, and very unhappy. This is when the Universe sent me a gift.

ONE DAY, OUT OF THE BLUE, MY OTHER BEST FRIEND KARA CALLED ME AND ASKED IF I WANTED TO MOVE TO AUSTRALIA.

Without missing a beat, I said yes. It was an escape and, until that moment, one I didn't know I needed. At the time, I wasn't scared or nervous; it was after we booked our flights that it got real. We decided to travel around Southeast Asia for six weeks to start off the trip. There were so many preparations and each one made me more anxious about going. I had to make some big changes in order for this trip to become possible. I had to change all my lifestyle habits, get a second job, and limit my finances to live only on the bare minimum. I cooked every meal and crunched numbers when grocery shopping. I cut down my social interactions to once per week, which wasn't too difficult, considering I had already alienated many of my friends. I got

numerous travelers shots that made me a little ill, but the hardest part about preparing to leave was letting go of all my stuff. This led me to my next lesson, surrendering the hold and emotional attachment of material objects. I didn't realize how much junk I kept just because it had a memory or person associated with it. I threw away and donated most of my clothes and knick-knacks, but I did box up a few things that I wasn't ready to let go of. When I came home many years later, I went through them again and let go of a few more things. I still have some of the stuff and each time I go through it, I get rid of more.

As the departure day got closer, I got more anxious and it hit me hard on the plane ride to Thailand. I ended up crying the whole way there because I was so scared of what I was looking for, and what I would find. Scared of losing what I had, the love of my life, and myself. Scared of getting into trouble and not having a safety net, and of not knowing what was going to happen, good or bad. I was terrified I had made the wrong decision.

Once we landed in Thailand, some of my stress leveled out. I did end up in a couple of predicaments, though nothing I couldn't get myself out of. One evening I lost all my friends at a full moon party and had to learn to enjoy it on my own. I felt awkward and uncomfortable until I ended up meeting a few Brits and made the most out of the situation. Another day I had a motorbike accident which led to road rash down the right side of my body and some unexpected financial stress. I was so worried I would run out of money and not be able to eat. One of our travel companions was on a different page and we didn't always see eye to eye. I tried to not let it bring me down. I learned the hard way that some cheap airlines don't include luggage and charge a ridiculous fee for not prepaying when you book the flight. Just another lesson in material objects and overpacking. It was also 40+ degrees Celsius, which is far too hot for my snow-loving Canadian blood. The heat made me miserable at times, especially if I'd been drinking the night before. The whole experience of Thailand was a huge lesson and possibly the most important. I learned to surrender to the Universe and let go of needing to always be in control. Sometimes shit happens in life and you need to accept it and carry on. Stressing about a situation does nothing except ruin your day or experience. Since then, I have learned to roll with the punches: I have been able to handle life more gracefully and level-headed. Positive energy breeds positive outcomes, and negative energy does the opposite.

THE BACKPACKER'S PATH TO PURPOSE

The next step in my life-changing experience was getting to Australia and starting a new life. My friend and I moved to Melbourne, found a place to live, got jobs, made some new friends, and settled in. The first six months were very difficult, and I felt lonely and unsure of my choices. I had missed my cousin's wedding and became homesick. Within the first few weeks in Melbourne, I had found out I was pregnant with Thomas' child. The doctor gave me one hour to make a decision about what I was going to do. Thomas had just learned a couple of weeks prior that his father was dying from cancer and he told me he didn't want to deal with me. My mother was my savior, supporting whatever decision I made as she listened to me cry hysterically. Considering what I had been putting into my body, including the travelers shots, I decided it was the responsible decision to abort. This was the hardest decision I have ever had to make and I had to make it by myself, on the other side of the world, in one hour. I never appreciated my family as much as I did that day. There are no words to describe the heaviness of the situation and the emotions that would come following it.

I worked numerous jobs to get some cash under my belt so I could see some of the country. To be eligible for a second-year visa, I had to do farm work for a couple months. I learned so much on that farm. It was a completely different way of life and way out of my comfort zone. I picked fruit, fed animals, sorted onions at an onion factory, shot off guns, and went on outback safaris. I caught yabbies, scorpions, and foxes, and ate rabbit and crocodile. I experienced a simpler way of life, which was equally as exciting as the life I used to live.

Some of the greatest lessons I learned were from the amazing people I met along the way. An Irish lad and I went on road trips and he taught me all about Irish history and culture. A man I dated taught me about love and how to communicate in a way that benefits the relationship. An Aussie girl showed me how to live mindfully and be present in the moment. My English hairdresser taught me how to open up and be adventurous. Another man I dated taught me about negative energy and how easy it is to transfer to others around you. A couple of Kiwi girls taught me about hospitality and how respectful friendships should be. There were so many cultures and ways of life I had never been aware of. These people, whom I am grateful to have met, widened my view of the world.

My next step on the road to fulfillment was moving to New Zea-

land all on my own. I was nervous but also extremely excited. Within a few hours at the first hostel, I met a few open-minded and caring people. I felt safe and comfortable, a feeling that has never left me. New Zealand is a beautiful country with extraordinary people and I hope to call it home again one day. This is where I learned my next lesson. *Surrendering to the unknown and breaking out of my comfort zone.* Traveling alone has been one of my greatest achievements - it showed me how to be comfortable in my own skin and that is something truly empowering. Becoming 100% independent was so far from where I was when I left Canada, three years prior. Near the end of my time in New Zealand, I knew it was time to go home and think about a career so I could continue on the road I had just discovered.

It took time and plenty of thought to figure out what job was right for me. My number one priority was to help people because I have always had a deep love for people and thrive off human interactions. I also knew I needed flexibility, and by this point I knew I was addicted to traveling and I was curious to see all the places my new friends hailed from. I wanted to snowboard all over the world and eat crazy food, I wanted to wander around old castles and learn different languages. After weighing out all my values and goals, it always came back to massage therapy. I decided to just pick something and jump right in. In British Columbia, massage is a regulated health care industry and the schooling is extensive. I knew this was the right decision from the first day - the techniques and flow came naturally. Finally, I knew who I wanted to be.

Traveling changed me in numerous ways. I became more mature - maybe that would have come with age anyway, but I think travel fast-tracked the process. I am less high-strung and anxious. Realizing that stressing about everything adds no value to life led me to be more level-headed and now, the big picture appears more quickly. I'm far more accepting of other cultures, people, and ways of life, but I'm especially accepting of myself, both my flaws and my strengths. I've become more curious and adventurous, even if it scares me. I am less nervous about trying things than I used to be, knowing there is more to gain by getting out there. *I set goals and I smash them. Goals are how I got here and how I will continue on the right path. They focus me.* I have learned how to communicate better and set boundaries within my relationships. My favorite thing I have taken from this whole experience is the ability to allow myself to be myself. I know my self-

worth because I decided what it is. I have learned how to allow my spirit to be free and I can choose my path. This was only possible by allowing myself to break down walls and get out of my comfort zone. Not everybody has the opportunity to travel but there are choices we can make every day that will improve our quality of life. Try that exotic vegetable at the market - it might end up becoming a staple in your diet. Take that kickboxing or pole dancing class you've always wanted to - it will help build confidence while building muscle. Jump out of that plane even though you are terrified of heights - it will be the scariest, most rewarding experience of your life. Write that chapter in a coauthor book - you never know who you might inspire. I wish we could all be cats with many lives but we have only been given one so let's make it count.

ACKNOWLEDGMENT

THANK YOU DAD FOR MAKING ME WHO I AM (AND SAVING MY BUTT ALL THE TIME), AND COOKIE FOR ENCOURAGING ME TO BE CREATIVE. RIP. ALSO THANK YOU LOLA AND AMANDA FOR BEING BY MY SIDE THROUGH THICK AND THIN.

(18)

I SURRENDERED LOVE ONLY TO RECEIVE ENDLESS LOVE

"You are art, master yourself, master peace."

BY: GAGAN MANN

GAGAN KAUR MANN

GAGAN KAUR MANN

Gagan Kaur Mann is a poet who goes by the name Sammar Blues. She is able to find beauty in all. Gagan cares deeply about the equality of all walks of life. She loves to travel and enjoys spending time in nature. Gagan is a natural born storyteller, and she loves to share her experiences in life through words and speech. She is often referred to as an old soul. She believes in kindness, honesty, and integrity.

www.sammarblues.com
ig: @sammarblues
ig: @gagankmann

HER ART OF SURRENDER

I was alive but I wasn't living
I was loving but I wasn't loved
I was searching but I couldn't find
I was lost
I was incomplete

I was on my knees, looking at the sky, in defeat
I put my hands together
Tears streamed down my face
Darkness had taken place
I needed light

In time

I stood up
Fists filled with dirt
I was ready to fight
For my life

I SURRENDERED LOVE ONLY TO RECEIVE ENDLESS LOVE

WINTER NIGHT - AROUND SUPPER TIME, I was born. My mother had decided on a home birth, in the village of Baloke which is located in Punjab, India. Youngest of three. We lived in a joint family – uncle, aunts, cousins, grandmother, and grandfather. The only person who wasn't in sight was my father.

I was unaware of his existence; I was too young to understand that he was away working in hopes of building a better life for our family. I met him when I was five years old, at our first encounter I asked him who he was, when he told me – I was delighted.

At last, the questions asked by the children in the village had been answered. I did have a father – my family was complete.

I soon realized he was not what I had hoped him to be. I would see my friends with their fathers and they would be treated with love and respect, I would look at them in awe, and later be saddened by my reality.

When my father was around, there would be silence. I was not able to freely express who I was, the wings that wanted to fly were held together in pain, waiting for the moment to be released. Every now and then, they would be, but he was never there to see. I lived in fear of my father. I was afraid that if I did anything to disturb him, there would be consequences. I desired to be loved by my father, desperately – I was aching to be noticed.

In later years, I met a man. We made eye contact – love at first sight or so I believed. He was a few years older than I was. I had given myself up in order to receive love. I craved delicacy and sensitivity. Instead I got supremacy, narcissism, disrespect, and suspicion. Loud voices, instead of the soft-spoken words that I had desired. Blame, the fire inside me had been tamed. Yearning for a real connection, a soul connection, in place of all the longing, I had eyes filled with tears from desperation and infatuation.

One of the many incidents I remember was him trying to convince me of actions that I had not committed. I would try to disagree; I would scream, "IT WASN'T ME." In time, I would give in and agree, "I DID IT, I DID IT, NOW WILL YOU PLEASE STOP TORMENTING ME." These accusations became my false reality. I was mentally abused, but still I stuck through. I remember thinking to myself, *Maybe, he does not know how to express his love. Maybe, my father loves me too, and maybe he does not know either. Maybe, silence is the way they show it, BUT WHY DON'T I FEEL IT?*

It started to impact all aspects of my life, I would walk into a room filled with whispers, smiles on their faces but behind my back they talked about my unseen scars. Make-believe. I became.

I felt awful, my character had been tainted. One side of the story was told and they believed it, forever changing their perspective of me, negatively.

I could not look into the mirror; I could not look into my own eyes. I could not believe how society can influence you to the point where you stop believing in yourself and start living in fear, of their thoughts.

What they say, is it true? Did I forget about what I did?

The words keep repeating in my head

Am I a slut? Am I a whore?

I'm around all of these people but I'm the loneliest I've ever been

Why do I feel like I'm going insane?

What will get rid of this pain?

Why are they doing this to me, what do they have to gain?

My energy has been drained

I cannot do this exchange

If I want to stay

Sane

The smile that I so often carried was starting to fade away. I held my head lower than I was used to, I tried to conform to their ways, but I was different.

I could not do it.

I REBELLED.

I LEFT.

I rid myself of

Complexity

Freed my mind

Of perplexity

I SURRENDERED LOVE ONLY TO RECEIVE ENDLESS LOVE

Repetitive thoughts
Could not get the best of me
Could not listen to his words
Of profanity
I started to believe in me
I gave up thinking
"What does he see in me?"
I started thinking
"How could I be the better me?"

They said, "You should not run away from your problems; you should face them." I agree, to an extent. I feel that you need to get away to learn that your problems may not be problematic. I was tired of being an assumption; assumes she does this and she does that. They did not know about my intuition or my intellect. I needed to escape so I could learn about self-love. I was on the road turning left to self-destruct, but I made a u-turn and loved myself instead.

That is where my journey began.
I surrendered them.
I let them go.

I said to myself, "If they do not love me, I do not need them." It took time to let go of feelings and emotions that I had carried for a while. Once I let it go, I grew into a woman who is indestructible. I had a goal, to love myself so completely that no individual could destroy me, and that also included me. I stopped living in my past and I started to live in the moment.

MY THOUGHTS SHALL ONLY BE IN THE PRESENT MOMENT, FOR IT IS ALL I HAVE.

The rumors did not matter anymore, I walked with confidence, their thoughts did not matter anymore. I did not believe in their words anymore.

I know who I am.
I am conscious of myself.
I am aware of my potential.
I am mindful of what I carry.

I do not carry hatred, not even towards him. I thank him. If it was not for that experience, maybe I would still be searching for love, from someone else. Maybe I would have never loved myself to this extent.

I was destined to be here
I was destined to meet you
I chose to sacrifice
I was destined to suffice

I wholeheartedly believe that the tragedies that I experienced were there for my well-being. Experience is knowledge, we cannot have the same experience twice. We are able to change our perspective to the situations that arise before us, either we can be angry at life and wonder why things happened the way they did, or we can learn from it and move forward. We cannot control what destiny throws our way but we can control how we act towards it.

I forgave myself
And finally,
I began to heal
I began to feel
What needed to be felt
I told myself the truth
I stopped covering up the lies
I told myself what needed to be heard
I rid myself of the disguise
That I had put before my eyes

I SURRENDERED LOVE ONLY TO RECEIVE ENDLESS LOVE

I uncovered myself
I put my chest to the ceiling
And I said
"TAKE WHAT YOU WANT"
Just leave me
With myself, feeling.

I needed to feel all of the emotions in order to truly heal. I had to understand where the mistakes were made and where I could have improved. Self-realization is more powerful than an intervention. Instead of people pointing fingers at me and telling me what was wrong with me, I figured it out, on my own. No one knows you the way you know you.

Now negativity does not exist where I stand, it cannot breathe when I am around. I speak my thoughts freely, always positively – looking at the bright side, there is no other way to be. I started to treasure the little things in life, the sun, the trees, the moon, the birds, and the bees.

Life became easier, it became light, I became free. Free of fear, free of greed, free of ego, free of all the things that my body was telling me to release.

ONCE I SURRENDERED, THE UNIVERSE SURRENDERED ITSELF.

I realize that I am temporary, and so are my thoughts. If I think about a situation several times, it does not change it – the only thing that remains is the strain I put on myself. I stopped carrying the weight of those around me. My pain is not someone else's to carry and vise versa. The actions of another individual should not affect me, as I should not feel guilty for what I did not commit.

I CAN ONLY BE IN POWER OF WHAT I CHOOSE TO DO AND I CHOOSE TO BE HAPPY.

I do not believe in bad days. Every moment that passes, I invite it in with open arms and thank the Universe for providing me with the strength to carry on, to move on, to be in a constant state of flux.

Now for love, I have a big heart and I am conscious of it, but

this heart is not just for me; it is for the strangers who need a smile on their face, or a soul who is searching like I once was and still am, for the children who need a hand to hold on to when they are feeling alone, like I once was. It is for the mothers who give without the expectation to receive, like my mother does. It is for everyone who needs love in their life, I am willing to give it, but it is without attachment. We are all going to leave one day, we don't know when or how, if we love without attachment we can love in that moment – without the fear of loss. Once we let go of that fear – we are able to conquer anything that comes our way.

I wanted change, so I became it.

Once I started my journey, I knew there was no turning back.

It took patience, it took time, but time is all we have.

I WAS IN THIRST FOR CLARITY.

I needed to let go of the thoughts that were circling my mind, day in and day out. I decided to do this by sitting in silence, focusing on my breath and my presence. I started by taking ten minutes out of the day, for myself to think about absolutely nothing, which in return gave me everything. Questions that I didn't know I was asking were answered.

It is hard to be selfless in a selfish world. I tried it and failed miserably. I would say yes to everyone around me in hopes they would be satisfied, until one day I asked myself, "Who will satisfy me?" That was the day I started saying no.

I say no to what does not serve me. This is not out of spite or hatred – this is out of self-love. I understand that my potential will be reached if I put the time and effort into it; if I am constantly being driven away from my priorities then I will never reach them. I stopped saying yes and started focusing on my vision, my success. This was a drastic change that I needed immeasurably.

My prize possession is myself – I do not say this in vain, I say this as I am finally able to look into my eyes every day and I tell myself – I love you and accept you for who you are. You are perfect to me. You are incredible and you will achieve all it is that you are yearning for.

I WANTED TO BE ACKNOWLEDGED, SO I ACKNOWLEDGED MYSELF. I WANTED TO BE SEEN, SO I SAW MYSELF.

I do not hold back my thoughts or how I am feeling. I am here today. Tomorrow never comes. Today is when change begins, today is when you decide what you choose to do with your life. Today. If I lived in tomorrow's world, then I would have never written this. I took a situation in which someone tried to destroy me and allowed it to blossom into a promising reality.

I stayed in the company of those who were not completely mine and once I realized that, I decided to create my own home, within myself. I forgave the ones who shattered me and put my pieces together on my own.

I listened to the calling within, it was screaming out for my attention. I was attentive, I gave it all I had, I gave myself. I started questioning myself and those around me. I understood that I have intentions so that must mean they have intentions,too. Whether they are good or evil, there is no harm in knowing. I would rather know than wonder. Knowing brings you a sense of clarity that allows you to live a life of peace and serenity.

I started to feel whole – the emptiness within me started to be filled. My suffering came to an end, my pondering why I wasn't loved came to a conclusion – that is when I moved forward. The regret I carried - I set free.

ACKNOWLEDGMENT

TO THE WOMEN IN MY LIFE WHO HAVE SHOWN ME STRENGTH THROUGH LOVE AND ACCEPTANCE. YOU ARE MY INSPIRATION.

NASIB, KINDI, KULWINDER, MANPREET & SIMER

19

SURRENDER TO YOUR INNER WISDOM

"Trust your inner wisdom, it has your best interest at heart."

BY: EFFIE MITSKOPOULOS

EFFIE MITSKOPOULOS

EFFIE MITSKOPOULOS

Effie Mitskopoulos, founder of Soul Body Healer, holds a Master's in Social Work and specializes in Holistic Psychotherapy. She customizes Western interventions with hypnosis, mindfulness, yoga, and energy work. Her commitment to helping others stems from her own healing journey. Despite hardships she had faced, Effie kept receiving messages that there was more to life than suffering and kept pushing on. Many times she felt like giving up, but hope and persistence kept her seeking knowledge, authenticity, spirituality, and, ultimately, wellness. Her journey was catapulted in 2010 by practicing Kundalini yoga and becoming a yoga teacher. She came to realize that healing occurs on all levels - mind, body, and soul. Because much discomfort stems from a mental-emotional-energetic cause, practicing mindfulness and hypnosis can shift unconscious programing, helping to manage emotional states, while Reiki and yoga bring balance and strength to the body and energetic systems by releasing unresolved emotions and energy blockages.

Effie has provided programs ranging from stress management, depression, anxiety, chronic pain, addiction, and trauma for thousands of people in many populations. She believes that every individual has special gifts and has the strength to heal themselves. It is her passion to help her clients uncover the root cause of their discomfort and release distressing patterns so they can live happy, peaceful, and meaningful lives. Her vision is the uplifting of humanity - for people to feel whole and well and free to express themselves fully, so that every interaction is loving and compassionate, supporting a peaceful world.

soulbodyhealer@gmail.com
www.soulbodyhealer.com
fb: @soulbodyhealer

AT THE AGE OF THIRTY-THREE, my life blew up. I had been in a six-year relationship with a man who I thought was my life partner and would be the father to my (unborn) children, and he left me. It was as good a break-up as could be. We cried together, clinging to the belief that we were not meant to be and "us" had to end here. Within a week, he moved out of our house and I was left carrying the fate of the rest of my life in my hands. Distressing thoughts plagued my mind: *I'm not good enough, I'm not marriage material, There's something wrong with me, How will I find someone to have kids with? The clock is ticking, Why couldn't he marry me? I can't do life on my own.* Emotions of grief, sadness, anxiety, and inadequacy lived inside me. I kept telling myself, *This was meant to happen, this is good for me somehow, even though I can't see it yet. There is someone else better for me.*

Have you experienced times when there seems to be one challenge after another? Negative life events can really bring up emotional turmoil. Life may seem hard or maybe you don't feel satisfied with how things are going. Maybe it's your job, relationships, or just a general level of discontentment. This was definitely one of those times when the ball was rolling from one difficult situation to another. You may have stories of when things were crumbling but the situation turned out for the best in the end. There may have been fight and discomfort but then you let go and things fell into place. Maybe you learned a lesson because of the hardship and found it was necessary to grow into the fabulous person you are, to obtain your dream job, or to put you in the right place to meet your sweetheart. You may notice that there was a series of events that had to occur in their perfect timing to lead to a grand result. So how can we experience more grace in life's hardships, trusting that there is likely some good to come out of it?

I had to use all my energy to suspend judgment and orient myself to the present moment. I used every coping skill I learned and taught to others from trainings, books, experiences, and clients. Even so, moving through the difficult emotions and dealing with my new life was challenging. I had two months of "bad" things occur. I made decisions based on what I thought was easiest instead of listening to my intuition about what was best for me. Intense emotions were clouding my judgment. I loved our house so much that I didn't want to leave and so sought a roommate to help pay the bills. This turned out to be

disastrous. People would like the house and then decide not to move in. Then when someone did, she helped herself to the utilities and food without paying for it! This created an atmosphere of tension and mistrust. Why was it so hard to find a respectful roommate? I finally got the message - living on my own was in my best interest. In grief that my previous life had ended and terror from not knowing where I would live, I asked the roommate to leave and started my journey to find the perfect apartment. Viewing after viewing showed depressing and expensive apartments that I could never call my home. The icing on the cake was when my iPad fell to the ground and shattered. I looked up and spoke to the Universe, "Are you done with me yet? I surrender, I trust you to lead me to a more comfortable place." That was when I got the full message, I surrendered my belief that I had full responsibility for finding the right home and asked the Universe to help me. I made a leap of faith and chose to trust that whatever home I ended up in would be growth for me. Moving out of a home that I loved was a big decision and I had to exercise patience. Then I marched over to my healer for an energy session. I followed my gut feeling and it was she who sent me the listing for the apartment I now live in. I made my home into a comfortable and beautiful place of my own that I love.

The general definition of "surrender" is to submit; a giving up of power to someone/thing else. I offer a different meaning: to surrender is to trust and follow your inner wisdom, while believing that every situation has been manifested for your optimal learning and growth, whether it's pleasant or unpleasant. So this is not a resignation at all, but an empowering and peaceful way to look at a situation. When we surrender, we can create a calmer experience amidst a challenge. Trusting and having faith in your inner wisdom or intuition honors your Divine Self (Soul). We can think of the soul as the energy within. Science acknowledges that we and everything in the universe are made up of energy. And since there is no energetic distinction between ourselves and everything in the universe, we are connected to everything and have access to all its information. Universal Energy contains information about every possible manifestation (past, present, and future) because it is the energy that creates all things. Universal Energy can also be called Creator or God or whatever feels comfortable. We can think of intuition as messages that come from the soul, which always point in the direction of growth. Thus, through intuition, we tap into

the wisdom of the Universe. It has within it information about every potential decision we make, our purpose, our gifts, how to use them, and how to manifest a joyful life!

For some of us, just having blind faith that things will work out is foreign and difficult to follow. One must trust and tolerate uncertainty. Conversely, it is in the mind's nature to try to predict the future so it can keep us safe. It's a biological function and an evolutionary learned behaviour. Surrendering goes against this natural tendency. Fear of the unknown is difficult to overcome in this uncertain world and so it drives our beliefs and behavior. However, we simply cannot know what is going to happen in any part of our lives. Faith is tolerating this mystery and letting go of this programmed fear. It is courageous to believe something that you cannot see - to believe that you are a part of an energy that is greater than you are and that it supports your growth. Then you are able to overcome any adversity. Surrendering puts you in a powerful vulnerability that connects you to your soul. It is a belief that taps into the energetic realm that manifests all things possible. When the negative events ball is rolling and we believe more negative events will happen, they do. Surrendering and trusting that the Universal Energy will organize your life in your best interests can turn uncomfortable events into comfortable ones. You meet people that point you in the right direction (e.g. my healer), you follow what feels right (e.g. the listing for my home), and you trust that the unfolding of events are in perfect order for your growth, despite the grip of fear. And poof! Your best interest manifested!

What we manifest for ourselves is contingent on our thoughts, beliefs, emotions, and decisions, which are influenced by many things. In psychological terms, surrender involves accepting unpleasant thoughts and emotions, thereby creating a more pleasant experience. It is a way to cope with these emotions. But it also assists us in making decisions that evolve the soul. My story of coping through a significant break-up and learning to accept being single and childless in my mid-thirties is an example. When I chose to stay in our house, I was trying to avoid change. I was trying to keep something that felt safe, comfortable, and certain. This ultimately wasn't the best choice for my evolution as a single person, and also as an individual who makes her own decisions irrespective of her former partner's influence. After the initial fire of finding a home was extinguished, I was left to sort through uncomfortable and confusing emotions, beliefs,

and expectations for my life. I am still moving through the struggle of what this stage of my life is "supposed" to be. On occasion I succumb to the needs and wants of what society dictates for a woman my age.

When I was a little girl, I didn't think much about having a family. I just thought that when I was big (age thirty), that would be my life. Society tells women that we go to school, get a job, get married, and have kids. This pressure, coupled with grieving a major relationship, tugged at the core beliefs that there's something wrong with me, I'm not good enough, and I'm unloveable. I was left feeling as if the clock was ticking if I wanted to have a family. I would receive lectures from co-workers and family advising me to be choosy with who I date, and make sure potential partners are marriage material and that they want kids. Believing that I needed to quickly find the perfect mate distressed me. The fear of not finding a life partner and not having the opportunity to become a mother filled me with despair. I caught myself in a whirlwind of anxiety about my unknown future, and grieving losses I hadn't even experienced yet, and may never experience. I had attached my current well-being to an expectation for my life that I wasn't even sure was mine. Physical (ego) desires and the external opinions of society, friends, and family were influencing the path I chose for myself, which was uncomfortable. In this way, I allowed others to tell me what was good for me instead of what I knew deep down was best. Then I remembered to access surrender.

In my initial planning talk with Cassie, I felt reluctant to share this story because I felt I hadn't overcome this deep-seated fear shrouded in negative core beliefs. I was depressed and would rather avoid the pain of bringing it up, but I kept an open mind and wrote anyway. Climbing out of that deep cavern, I gravitated to other singles my age and recruited friends into my circle of support. Less often I catch myself in future-thinking and then reorient myself to the present. I cultivate gratitude for my current life and surrender.

The mantras that I choose to believe may be different from yours, but I will share what helps me calm my nerves.

I live an unordinary life. I focus on my friendships. I am connected and cared for by others without being married. I love my space. I don't need to have children. I love my life as it is. This is good for me. I focus on my gifts and talents, and express them in my career endeavors. I am held by the Universe and accept all that manifests as that which is in my highest good. There is a

grand design and it is manifesting as long as I listen with an open heart and mind, as long as I am authentic with myself and others, and follow the Divine Guidance. Roadblocks are necessary.

I let go of societal and familial expectations, trust that what's meant to be is on its way in its own perfect timing, and as long as I listen to what feels right, I trust I shall be led to my best possibility. I also believe that there are so many possibilities and the present manifestation is never the wrong one. This life stage is a learning experience that enriches my life, even if it is uncomfortable. My purpose and path is always molding itself to the decisions I make in the present. I take full responsibility for my thoughts, emotions, and actions in the present.

Following my intuition was a gradual process of learning to detect my soul's directions. This required me to develop certain beliefs and sensitivity to inner sensations. First I learned to trust that I have inner wisdom. When I need to make a decision, I come to a stillness with the intention of feeling my gut reaction. This is where each of our truths live. When you ask yourself for guidance, a Yes feels expansive and freeing. A No comes with anxiety, contraction, and discomfort. Sway testing and muscle testing are other ways of tapping into the soul by using the body to get answers of Yes or No. So when you're tapping into the wisdom of your soul, get clear about where your desires and fears are coming from. Are they externally influenced? Yes may come with fear of the unknown. No may come with a strong desire to pursue an action. Keep in mind personal needs and wants and those from society, and whether or not they are the same as your soul's highest good. A decision coming from your soul feels uplifting and effortless. Once you've learned what your highest good is, surrender despite any fear. Then keep on refocusing on this highest good. For instance, giving in my notice to leave my house was scary because I didn't want to end up in a depressing, expensive apartment alone, but I did it anyway! Even when my former partner and I were breaking up, ego (physical needs) wanted to cling to the relationship and convince him to stay, but deep down, I knew the breakup was best for my soul. I keep in mind that uncomfortable sensations will arise and my current life is an opportunity to work them out. So far I am working on feeling connected and cared for when I am alone. I build up the belief that I am worthy even if I'm not in a serious relationship. I'm also learning to make my own decisions without a

partner's influence. I'm learning to consider my needs first as I navigate my career direction without having to consider a partnership and children in the near future. My thoughts and emotions keep on fluctuating as I move through this difficult stage but keeping the surrender mindset is helping. As I put into practice the belief that things work out the way they're supposed to, over time it becomes stronger and more accessible.

Surrendering can bring grace and peace to challenging situations. We learn what is right for us and our higher purpose in life, which ultimately leads to a more pleasant experience instead of intense and sometimes debilitating emotions. I was originally not going to write about the break-up or the turmoil surrounding being single and childless. I took it as a sign to work on accepting my thoughts and emotions by writing this chapter. As I read, write, and surround myself with the concept of surrender, I find myself moving through this stage and state in my life with much more acceptance and contentment. I see that writing about it is good for me. **Now I know why I felt pulled to be a part of this book in the first place.**

ACKNOWLEDGMENT

I AM SO GRATEFUL SPIRIT PLACED ALL THE SUPPORTIVE PEOPLE IN MY PATH SO THIS CHAPTER COULD BE MANIFESTED!

(20)

BECOMING COMPLETELY UNDONE

"I could no longer see myself in any other way until I broke the agreements that were made."

BY: CASSIE JEANS

CASSIE JEANS

CASSIE JEANS

Cassie Jeans is a woman from Ontario, Canada, intertwined with a Mexican heritage. She writes for the joy of seeing words on paper. Since she could, she has found her voice through her writing. This helps her understand her world better and why she feels so deeply. She is a mother, a wife, a curious creature with a desire to be outdoors connected to the earth. She has a belief in humanity and an innocence in the way she views souls on this planet. Because of her unraveling, she shares her story with the intention of letting others come to the full realization of who they are. Her goal is to create a legacy of words and bring beauty into this world with her art while inspiring others to do the same.

www.cassiejeans.com
fb: CassieMJeans
ig: @cassie_mjeans
hello@cassiejeans.com

"FOR A SEED TO ACHIEVE ITS GREATEST
EXPRESSION, IT MUST COME COMPLETELY UNDONE.
THE SHELL CRACKS, ITS INSIDES COME OUT, AND
EVERYTHING CHANGES. TO SOMEONE WHO
DOESN'T UNDERSTAND GROWTH, IT WOULD
LOOK LIKE COMPLETE DESTRUCTION."
- CYNTHIA OCCELLI

HAD NO IDEA WHAT surrendering was for the many years I participated in its sacred practice. I was far more comfortable in resistance, in numbing my emotions, in pretending like everything was fine. I resisted surrender so much that instead of gliding into my unraveling, I would be forced into surrender, kicking and screaming. Digging my heels in was my first instinct. This was the beginning of my journey into the deep inhales and exhales while the reality I had created around me was falling apart. I was in full rebellion, full immersion in the abyss of not knowing myself at all.

I wanted to turn a blind eye to what was happening with my life, especially to the voice that was screaming inside of me. I wanted to keep the walls of the box securely placed around me even though I was the volcano that was about to erupt. *Words like personal development, soul work, spiritual practices, daily practices, meditation, whole body care, self-love, self-worth, personal growth* were a foreign language to me. I had this feeling coursing through my veins for months, and the only antidote to the rage building up inside of me was a list of words I knew nothing about.

I hated myself in a way that was incredibly destructive, but what was worse than this was that I had no idea who I was. It was like hating a ghost - you know it's there but you can't touch it. *I remember thinking to myself, Is this really what I signed up for? Is this all there is?* These questions circled within me for months whenever I would give them breathing room to exist. These thoughts terrified me, I knew something was wrong but I didn't know how to fix it. When did I stop dreaming? When did I stop believing in magic and miracles? When did I stop loving myself?

Entering into motherhood was one of the catalysts for the lists of questions that were bubbling in my brain. The realization that I was to be responsible for supporting these two beautiful beings with more

than just food and shelter, made me start to question my validity as a human being. Who was I to teach another soul how to live life? I barely understood mine. What should have been the most blissful years of my life were greatly affected by postpartum depression. I remember thinking to myself, *It would probably be better for everyone if I just left. I don't think I'm cut out for this. Everyone would be better off without me. I judged these thoughts so severely in my mind. Cassie, what's wrong with you? These are supposed to be the happiest years of your life, you wanted this...* And that right there was where I had to dismantle my entire life course. That was a lie. I didn't know what I wanted. I kept going with it, whatever *it* was.

Thankfully I was able to get a handle on my hormones through an incredible nutritional cleansing system I still use today that created space for my unraveling and would open up many doors of opportunity for personal growth. A series of small steps that on the outside look oddly simple, these created a pathway to my core desires for my life. *Curiosity paves the road to purpose.* When we start paying attention to the questions we are asking in our head and then hold space for the answers to come into our mind and heart, we tap into purpose on the soul level. When we stop believing ignorance is bliss and we start bringing our shadows into the light, we tap into a deep rooting of self-love on a spiritual level. I knew none of this at the time but my soul knew, God knew, Universe knew. I think about how I see life now compared to how I did then and tears of gratitude spring to my eyes. We are all part of the most beautiful love that can be seen in the most miniscule ways every single day. I am now in awe of our existence.

Before I could love from this place of abundance and ease, there were some definite steps that I had to take. During these steps, every single relationship around me changed. I was surrendering to my nature. I was the hurricane that was disrupting everything around me. This was uncomfortable to say the least. I was restructuring the foundation that I had built my life upon and in my desire to know myself, I was essentially sweeping the rug out from underneath everyone else who thought they knew me. I had to surrender to the phrase, *come what may.* Self-acceptance comes with a lot of light and a lot of shadow. I never knew that by starting to answer the question of *Who am I?* I would also be creating conflict, opposition, misunderstanding, and genuine frustration in others. I never knew the true meaning of this quote by Don Miguel Ruiz until I started living through it:

"WHATEVER PEOPLE DO, FEEL, THINK OR SAY, DON'T TAKE IT PERSONALLY."

Sensitive by nature and with an ability to feel other people's emotions, energies, and vibrations, the lesson of not taking anything personally was incredibly foreign to me. What did feel right, however, was acknowledging that even the good and the bad perceptions that others have about me are not ones that I have to adopt for myself. I could choose. **Choice.** This single realization was surrenderance. I could choose my path, my thoughts, my life. I could choose to be fully immersed in my growth, come what may. I chose me. What else could I do? Lose myself in raising children? Lose myself in my marriage? Lose myself in my career? I tried that and it brought me to my breaking point. I remembered the hunger of love's first embrace and this time, I was hungry for myself. My time became consumed with personal development for a full year. Podcasts, books, seminars, retreats, coaches. As I listened to the women and men who had gone before me and their stories of unraveling, this beautiful light and gratitude poured into my life.

Gratitude will recreate your entire life. It absolutely recreated mine. I started seeing this beautiful world through the eyes of gratitude and everything that I thought I didn't have stopped being important. Gratitude is a sweet freedom from the feeling of inadequacy. Why do we feel inadequate when many of us live in abundance? I believe we are searching for something external to fill a void that can only be filled from within. I had no idea that I was feeding emotions that were keeping me in a state of constant disappointment and low self-worth. Without the gratitude mindset shift, I know I would not have found my soul work, my purpose, my joy. Instead of reaching for more from outside of yourself, dig deep into yourself and feel into all that is speaking to you from there.

Even though my perspective was changing, there was still work to be done around surrendering to the internal rhythm of my soul work. We are more than the physical parts of ourselves. **Recognize that there is never an end to this.** Perfection is completion and we are blissfully chaotic on our best days. Allow the unraveling to happen and place as little resistance on it as possible. The rigidness of trying to keep life all together and the voices of inadequacy in my mind were suffocating all creative expression in my life. I learned that

I could not hold it all together. We are like water, designed to ebb and flow. To come in and to wash away. To create waves and to also be tranquil and still. The life I was living was all about control and zero bliss. My body would be the siren for a new wave of change and she was not going to take any more of what I was giving her. I wouldn't stop, I refused to slow down. I didn't want to face my life, I wanted to run. There was no room, I had filled it up with stuff and I was racing towards an end goal that did not exist. My body spoke up for my soul and stopped me dead in my tracks. Not long after the birth of my second child, I was diagnosed with scoliosis in my spine. Anger was my first reaction and it also became my fire. I refused to accept the diagnosis but in this refusal, my life had to change. I quit my job and I sought treatment. I was graced with a woman who could help me and the first time she laid hands on my lower spine, I cried, but not from the physical pain. I cried because of the wound-up emotions and the binding of my anger. My refusal to stop crumbled in that first adjustment.

SLOWLY, SLOWLY, THE HEALING COMES. SLOWLY, SLOWLY, THE BINDING COMES UNDONE.

This would be a long journey. A series of events all directing me home. Home to my voice. My truth. My message. My curiosity. My joy. My childlike ways of viewing life. We make peace with our shadows by letting them be heard. No more running, it was time to sit with the grief of realizing I was wasting time, avoiding my gifts, and settling for a lackadaisical approach to life. I gave voice to my pain and I allowed myself to speak. This was not an overnight process. Months and years went into this, none of which I would change. I would be lying if I said this process of surrendering is easy. We associate this word with giving up, throwing in the towel. Well, there are truths to that. Giving up on a life that suited you at one point but no longer does is tough. Habits, perceptions, excuses, beliefs, they all have to change. Throwing in the towel on relationships, on jobs, on what others expect takes an intense amount of courage. Surrender is not weakness, it is a choice to take a different course. It is a choice to stop fighting and resisting and to give in to what is stirring deep within your soul. It is acknowledging that you are more than a physical body, you are in union with your whole being and all parts of you must be heard.

PEACE COMES WHEN WE LEARN THE ART OF LISTENING.

Each of us has a unique path to walk, an epic journey all our own. Truly exciting when we see the ownership in this, but somewhat daunting when we believe we don't have a say. Nonetheless, the path is ours. There is an internal guiding system happening within us at all times. My mom calls it her compass. I call it the Wisdom Within. The voice of the Divine Feminine, ancient since the beginning of time and a voice I ask to be present in my life daily. This is the sweetness of surrender - an ease in the aftermath joined by this incredible feeling of self-assuredness, not derived from arrogance but derived from support from the entire Universe, including God, and Mother Earth. That is the net that catches you as you cease control and let go.

TRUST THAT SOMETHING WILL CATCH YOU.

Even when it feels like you have been falling forever, something will catch you as long as the heart is open to listen. Closing off oneself is not the answer. Trust the process of creating the sacred life completely. Soon after this period, it is common for us to tap into the desire to create and share our gifts. For me, writing and speaking words were my sacred places and I became ready to share. After the year of postpartum and opening up my heart privately, I was ready to test the waters publicly. This was terrifying but worth every sweat of fear. I rose with a ferocity for life and for the story that was within me. I let the child of my youth have her say, and she wanted to be heard with the voice of wisdom and resonance for anyone who needed to hear words that their soul was aching for. I let love lead me, I forgave myself and anyone else whom I never thought I could. I decided to like myself and to this day, I like me. I am here to inspire people with my words. That is it and I humbly accept this calling.

This is surrender. This is going to the depths of the soul, through the muck, the shame, the hurt, the wounds, the tears, the rage, and landing in this sweet place of seeing the infiniteness of our inner being. Seeing that we all have this inside of us. We can no longer see hate as an option because love stands in its way and says, ***"All are welcome here. All take up space here. All are loved here."*** And the light in these words transforms the hard parts so they are not so hard anymore. Our soul feels wrapped in the truth of this eternal embrace.

BECOMING COMPLETELY UNDONE

You are divinely loved and supported and when you lean into that un-derstanding from inside the cells of your body, you radiate a life force that sparks others to rise. Every day is a beginning. Every day is new. Agreements we make in our unconscious life must be brought out of the shadows and into the light. We must examine what we once said yes to and hold it up to our refining. What can stay? What must go?

ACKNOWLEDGMENT

I WOULD LIKE TO THANK EVERY KINDNESS THAT HAS EVER COME MY WAY, EVEN IN THE TIMES WHEN I COULD NOT ACCEPT IT. ESPECIALLY TO MY FAMILY WHOM I ADORE BEYOND WORDS.

Golden Brick Road
Publishing House

Locking arms and helping each other down
their Golden Brick Road

At Golden Brick Road Publishing House, we lock arms with ambitious people and create success through a collaborative, supportive, and accountable environment. We are a boutique shop that caters to all stages of business around a book. We encourage women empowerment, and gender and cultural equality by publishing single author works from around the world, and creating in-house collaborative author projects for emerging and seasoned authors to join.

Our authors have a safe space to grow and diversify themselves within the genres of poetry, health, sociology, women's studies, business, and personal development. We help those who are natural born leaders, step out and shine! Even if they do not yet fully see it for themselves. We believe in empowering each individual who will then go and inspire an entire community. Our Director, Ky-Lee Hanson, calls this: The Inspiration Trickle Effect.

If you want to be a public figure that is focused on helping people and providing value, but you do not want to embark on the journey alone, then we are the community for you.

To inquire about our collaborative writing opportunities or to bring your own idea into vision, reach out to us at:

www.goldenbrickroad.pub

Goals, Brilliance, and Reinvention

Join us at the social

www.gbrsociety.com

GBR Society is a community of authors, future authors, readers, and supporters. We are connected through Golden Brick Road Publishing House; a leadership, empowerment, and self-awareness publisher. The GBR empire is built on sharing opportunity. It is a brand built on being a true community consisting of friendship, allies, support, advancing with each other, philanthropy, and having each others back. We struggle together and we flourish together. We are a community budding with endless ongoing love. Our authors are real people, continuously looking to grow in their personal and professional lives which also makes them readers and supporters to others in the growing community. We want to make this motivation contagious by inviting you in to meet and grow with us. Get to know the real people behind successful author brands and careers. Build friendships with motivated people and find your own voice. We have been said to be guides in helping others discover their own strength; each person is their own best judge and best healer. No one does it for you, they can only share options with you.

Join us as a reader and gain a wealth of insight from our authors and featured guests, while receiving access to exclusive advanced books, online and in person events, book clubs, summits, online programs, retreats and special offers. Learn from us how to advance in your personal and professional life. Access information on what interests you choosing from health and wellness, sociology, human rights, writing and reading, creating a business, advancing a business or career, and personal development including self-esteem, introspection, self-discovery, and self-awareness.